I Fought the Law

I FOUGHT THE LAW

Photographs by **OLIVIA LOCHER** of the
Strangest Laws from Each of the 50 States

Foreword ✕ KENNETH GOLDSMITH
Interview ✕ ERIC SHINER

CHRONICLE BOOKS
SAN FRANCISCO

Introduction

Hello, I see you've discovered my book! The work you are about to experience depicts America's most unusual laws. Several of them remain on the statute books, the majority of them were at one point removed, others never became laws (but came close!), and a few of them are complete myths.

I Fought the Law was born casually one evening while I was photographing a friend. Out of nowhere he said, "Hey, do you know it's illegal to have an ice cream cone in your back pocket in Alabama?" I didn't have an overwhelming response or reaction to his comment and our conversation quickly moved elsewhere. Strangely, however, his allegation kept coming up in my thoughts for a few months afterward.

After this notion about the ice cream cone came back to me several times, I turned to the World Wide Web to investigate. After all, I'm a strong believer that if an idea pops into your head more than three times, it's one you need to trust, as it's most likely good.

It turns out that while in Alabama it is *not* illegal to have an ice cream cone in your back pocket, it once apparently was in Kentucky and Georgia. This performance was deemed unlawful in the 1800s. The legend suggests that it became common practice for horse thieves to lure horses away with ice cream cones. The horse, unable to resist the sweetness, would follow the thief, resulting in a situation where the burglar could announce, "I didn't steal him, he followed me!" My

caption describing this law remained "Alabama" because I became fascinated by how often bold statements could be appropriated, lost in translation, easily believed, and taken as fact. I was never the kind of person who cared much for random facts, but all of a sudden I became completely enthralled by unusual laws and couldn't stop searching for more.

As I continued investigating, I found there was no shortage of people claiming certain actions were illegal in different states, and that once any of these got out they seemed to spread like wildfire across the Internet. I also discovered that this was not a new phenomenon—fact books were published on the subject as early as 1978! Equally interesting, there was often no information as to where and when these wild statements were coming from or proof that the laws they claimed had even ever existed.

I quickly became fascinated with the insane regulations being mentioned, and because they were all very visual, I knew I had found a new photography project. I gathered my fifty favorite alleged laws, one for each state, and started producing an image for each in my studio using friends and acquaintances as my subjects. I also decided to withhold whether a law is fact or myth because, as an artist, I responded to the ambiguity of the brief captions standing alone.

Typically, all of my individual images in a particular series stem from a single premeditated idea that dictates everything for that project. *I Fought the Law*,

however, was a slightly different exercise because each image's caption served as its individual concept. Adhering to the captions became very meditative for me and proved to be an interesting way to make conceptual work.

I created the fifty images that comprise *I Fought the Law* between June 2013 and June 2016. They were all shot at my studio and apartment in New York City or my hometown of Johnstown, Pennsylvania, and made for incredibly pleasurable and unique scenarios to photograph. While some of these "laws" may seem like common sense, others really surprised me when I found out they were truthful. . . . The next time you visit Connecticut, for example, you can rest assured that the pickle you are about to eat passed a bounce test with flying colors.

x, Olivia

...And the Law Won

Foreword by Kenneth Goldsmith

X In December of 1965, the Bobby Fuller Four released a 45 rpm single called "I Fought the Law," an anthem about being broke, committing a crime, and getting sent to jail to break rocks under the hot sun. Paired with Sam Cooke's 1960 "Chain Gang," these songs evoke images of men in striped pajamas chained together, swinging sledgehammers, pulverizing rocks into gravel.

Though chain gangs are now the stuff of the funny papers, even a moment's pause for thought will reveal how horrific the reality truly was. Along with tarring and feathering, public executions, and Jim Crow, chain gangs seem to fall into that "bad old days of America" category. But in 1995, Alabama reinstated chain gangs as part of a get-tough-on-crime policy. At the end of the millennium, prisoners were forced once again to wear leg irons joined by eight-foot-long chains and made to crush large stones into pea-size pellets for ten hours a day. The cruel irony was that the punishment was Promethean: State highway officials said they had no use for their crushed rocks.

The song's title, "I Fought the Law," tells only half the story; the rejoinder—"and the law won"—takes on a special resonance in light of Olivia Locher's photographs. Outdated, eccentric, and seemingly useless laws are still on the books and can be reenacted and reimplemented, often with devastating results on human lives. Unfortunately, the law wins most of the time.

These ambiguities are a disaster for the legal system, but it's the exact thing that propels art; hence, Locher's purposeful appropriation of misinformation—laws that might not actually be laws at all—is an act of political critique. In this context, her bright, crisp, and readable images become satirical and cutting. But it's on this edge—the tension between the comedic and the tragic, resulting in farce—that Locher's work finds its true force. Her photographs are acts of civil disobedience, in the tradition of Honoré Daumier or Francisco de Goya, powerful social commentary wrapped in clear, populist visuals. Custom-tailored for the digital age, they're instantly readable and digestible; and like Daumier or Goya, they're as comfortable in commercial magazines as they are in the art gallery.

Michel Foucault famously writes about how punishment, once upon a time embodied and corporealized, evolved into a state of dematerialized fear, one that invisibly permeates every thought and action, controlling behavior more efficiently than public flogging ever could. Foucault's paradigm could be termed "distributed law," anticipating the way that technology (first through CCTV cameras, then through social media) distributes effect, completely bypassing physical presence. The fear that a smartphone might capture you spitting on a sea gull—as one of Locher's captions reads—will prevent you from spitting on a sea gull. Your actions are determined by

your pervasive trepidation; your ability to evaluate the worth of a law is overwhelmed by your fear of being caught breaking it.

That's only one side of it. The other is that law is in full, brutal force applied to bodies on the ground. One could, for example, imagine Locher making a photo with a caption stating, "In Minnesota a cracked taillight on your car is punishable by death." Sounds absurd? Philando Castile ended up with four bullets in him for that exact reason. And his death wasn't the first time he was bothered by such "absurd laws." Over a period of thirteen years, the African American man was pulled over forty-nine times for minor traffic infractions so ludicrous that they sound as if they could be the subject of a Locher photograph: turning into a parking lot without signaling, failing to repair a broken seat belt, driving at night with an unlit license plate, and driving with tinted windows. Nestled within those little laws is big money: Castile—a lower-income person—generated a total of over $6,000 worth of revenue for the Saint Paul municipality. Literally and figuratively, death by a thousand cuts. Similarly, in Texas, many lesser-funded women's health and reproductive rights facilities couldn't stay open because they were subject to lots of "silly little laws," such as requiring doorways to be a certain width, or stating that doors had to swing in a certain direction, or that only a very expensive type of flooring could be used in clinics; they even dictated that water flowing from drinking fountains had to be at a precise angle. Like Castile's bill, all of these little laws added up to big expenses. Many clinics couldn't make it. "Absurd" laws became a very effective tool of political agenda.

Half of Locher's project is based in language. She draws her caption texts from novelty paperbacks that collect odd laws, as well as from websites such as dumblaws.com. But while a closer look at those texts reveals many of them to be based in truth, they're not actually truthful. They're versions of laws, therefore versions of truth. Take, for example, Locher's caption, "In New Hampshire you can't tap your foot to keep time to music," which she based on a text she found at dumblaws.com. A little bit of research reveals that there might not actually be a law stating exactly that; instead, it appears that dumblaws.com misinterpreted New Hampshire law 179:19 Entertainment and Entertainers, which prohibits anyone underage from being employed as a dancer, defined as "a person or a group of people who, with or without compensation, move their feet, or body, or both, to the accompaniment of music in a premises approved to sell alcoholic beverages. . . ." While dumblaws.com's excerpting makes for funny clickbait, its reduction—like Castile's cracked taillight—is misleading, and in the wrong hands could result in catastrophe. By perpetuating legal falsehoods, they somehow become true, as in 2015, when a New Hampshire state representative was asked about that exact law from dumblaws.com. He apparently didn't know the context either: He was quoted as saying, "You can't tap your foot to music in a bar, that one was repealed a few years ago."

Locher's photographs cannot be mistaken for either law or truth; they can only be art. Art embraces slippages, ambiguity, and contradiction; it feeds on disagreement and misinterpretation—after all, there is no one right way to experience an artwork; all ways are equally correct. Law, on the other hand, is less generous, less playful. Laws are written to be obeyed "to the letter of the law" but in reality are twisted through "argument" and "logic" often to be anything but logical, let alone just. Law is as slippery as art but won't admit it; its refusal results in dizzying contradictions. Off-kilter and spinning out of control, Locher's works give it just the nudge it needs, helping it fall over. By confounding law with art, Locher fought the law, and the law lost.

A Conversation Between Eric Shiner and Olivia Locher

June 28, 2016

ERIC SHINER Have you, Olivia Locher, knowingly or unknowingly, ever broken the law?

OLIVIA LOCHER For the most part I'm a do-gooder, until it's time to make photographs. In art school I was shooting a lot of nudes while trying to discover my personal style. During my sophomore year I took a class titled "Nude, Naked, and Raw." Every other week the students needed to present work for critiques. I'd take weekend trips to my hometown to work on projects where I would have people pose undressed. They would mostly frolic around just slightly out of sight from the public eye. I discovered that one model's father was a police officer, and he was outraged that I was photographing his daughter. I became aware that the majority of the Johnstown police department had a personal mission to catch me. This, of course, made shooting a lot more fun and exciting! They never found me. I also abandoned and outgrew shooting in this style pretty quickly. Luckily, I found a love for the studio, where nothing is off-limits.

ES Your photographs are always playful, witty, colorful, and delicious. You seem to have your finger directly on the pulse of the art world, the fashion world, the world of advertising, etc. How do you think you developed such an all-seeing eye?

OL I think my secret is to indulge in every form of media and consume more than I can handle. I find it crucial to understand what's happening with art and fashion both contemporarily and in history. If something doesn't lie in my taste or interest, I don't ignore it; I simply make a note of it. I've always found myself attracted to both high and low culture and the intersection of where they meet.

ES Did you always overindulge in media?

OL To a certain extent, yes. Growing up, I became obsessed with certain things. One of them was fashion magazines! I remember going to the bookstore and stealing every subscription card from the fashion titles that were interesting. I slowly started subscribing to them all. *W* magazine was the most influential one for me; their editorials were insanely creative. I got my start in photography around the age of sixteen by mimicking what I saw in editorials by creating self-portraits. When I went to SVA [School of Visual Arts], my fashion roots stayed with me, but I became far more interested in fine art. Currently, I find myself in a lucky position that my practice forces me to observe everything

creative. For the past few years I've photographed backstage at New York Fashion Week for *W* magazine. Doing so has allowed me to have an exclusive sneak peak at the direction design is moving toward. There is such a wonderful cross-pollination happening right now with the art and fashion world, resulting in a lot of brilliant collaborations.

You are originally from Johnstown, Pennsylvania, site of one of the greatest natural disasters in American history. Did the mythology of the flood help shape your (at times) dark sense of humor?

OL The great flood of 1889 becomes part of everyone from Johnstown's roots. There are little reminders of it everywhere you go if you look closely enough. There are spots marking how high the water climbed on surviving buildings, where the water reached a height of sixty feet in some places. The total death toll was over two thousand people, and a cemetery near my childhood home houses 777 unmarked graves. Growing up, I'd always hear people's stories that had been passed on to them from previous generations. Johnstown recovered but was hit with two more major floods. Apparently, Johnstown was once a city that possessed substantial industries and attracted tourists, but it seems it was never able to fully recover after the last flood in 1977.

ES What's your personal experience with Johnstown like?

OL From my own experience, Johnstown was always a slightly depressed Rust Belt city. It's a place that doesn't offer its residents much to do, and most of the youth seem to keep a close eye on an easy escape out. Interestingly enough, I have found Johnstown seems to breed a strange creativity. Johnstown allowed me to be a daydreamer. Its mundane nature encouraged me to space out and be a weirdo. I think there may be something in the water, because there are a lot of very unexpected people working on very creative and slightly bizarre projects. It's some of the purest outsider art I've ever encountered.

ES Can you give me an example of this?

OL I knew a legend of a middle-aged man whom my mother encountered about ten years ago. All I knew was his name. He predicts the local weather by using these intensely intricate sculpted hats that look like they could be found on another planet, but he constructs them himself. I made a habit to search for his name on the Internet to see if anything came up—after all, we live in a world where practically everyone is fully documented on the Web. I almost gave up hope until I recently discovered video footage that a friend of his recorded, allowing me to connect with him. His stories and theories are fascinating, and he practices this technique obsessively with no hopes of having anyone pay any attention to him. I can think of a handful of others who have equally unique creative habits that are very specific to Johnstown. It's a place that really accommodates these behaviors. I often visit and still find much inspiration there a lot of the time because of the creative community.

ES I know that you are an acolyte of Andy Warhol. How did you first encounter his work, and what did it say to you?

OL I was privileged to spend much time at the Andy Warhol Museum throughout my entire life. Seeing Warhol's work was my first true encounter with the art world at large. I visited MoMA and various

other art institutions multiple times as a child on vacation, but everything went over my head and was of no interest to me. I wasn't ready for Rauschenberg, Stella, Newman, or Rothko just yet. Warhol's entire collection of work has this beautiful quality and subliminal draw to pull someone in; I fell hard for his work. When I was a teenager, my visits to the museum became a lot more observant and lengthy.

ES Which works from Warhol's collection left the biggest impression on you?

OL Warhol's films were my first true art love. I instantly took to the screen tests. What I found so interesting was that they were moving portraits; no one was actually auditioning for anything. Right in front of my face I was seeing the most interesting people I've ever encountered in my life through his films. I was fascinated watching their expressions melt as they sit staring into the camera that's confronting them. You'd think you would see their insecurities, but most of them had this effortless cool factor. Warhol's film *Blow Job* was very intriguing for me because of its subtleties. Showing only his subject DeVeren Bookwalter's face in the frame during the process of his climax expressed so much without being traditionally explicit. Yet, the work hits a nerve; its beauty and simplicity has forever haunted me. Warhol's work is still the first that I look to for inspiration, and having the museum to visit is such a gift. *I Fought the Law; New Hampshire* is directly inspired by Warhol's *Dance Diagram [2] (Fox Trot: "The Double Twinkle-Man")*, 1962.

ES Tell me what it's like being a young photographer in New York City in 2016.

OL Sometimes I feel as though I do living in New York all wrong! I'm such a homebody and often don't take advantage of all the city has to offer. I'm not one who tends to aimlessly wander, so everything I engage in becomes highly planned out. I'm a true creature of habit; I find little rituals and allow them to be a recurring part of my day to day. For example, I've been practicing Transcendental Meditation since 2013 and meditate twice a day, every day, for twenty-minute sessions. I'm one of those people who enjoys following my own itinerary. On the bright side, this permits my mind to be constantly engaged and focused on my practice. I set up my studio inside my Midtown apartment, allowing me to be on the clock 24/7. Surprisingly, my studio is my favorite place to be in Manhattan; everything I desire or need is right there. I have a lot of studio visits and love to cook dinner for my friends. I tend to appreciate life's more mundane activities; I really enjoy going to the grocery store.

ES Can you explain to me what your practice looks like?

OL When it comes time to make photographs, my practice is extremely bare bones and simple. I personally do all the styling and my brother Brandon serves as my assistant. I photograph friends or individuals who have qualities that I find familiar and attractive. I enjoy working with everyday people because non-professional models reveal more and offer a unique experience. All of my photographs are highly premeditated, permitting my subjects the opportunity to simply step into the frame. I don't want to paint the picture that I do nothing but work, although that's sort of truthful. Life and art become so intertwined. Something I find beautiful about New York City is everything happens eventually. Any artist whose work I have a desire to experience will likely exhibit with very little wait due to exceptional

curation in galleries and institutions. I spend very much time looking at art, going to the cinema, and attending musical performances.

ES Can you explain the process behind creating the images for *I Fought the Law*?

OL Some of these images were shot under highly unusual circumstances, often because of the unique concepts. On a few occasions I was forced to create an on-the-go studio. As a result, some of the images ended up having a large uninvited audience. The Alabama photograph was a good example of this. I needed a pristine ice-cream cone to document its process of melting. I couldn't bring one back to my studio because it would have already melted in transit. I went to the local ice-cream stand in Johnstown armed with a backdrop, my mother and brother as assistants, and one of my close friends, Jackie, to model. I'm super crazy about the small details of my photographs, so I begged the girl working to make my cone with an American flag wrapper that I sourced and brought along. With our close-to-perfect ice-cream cone, my mother and brother held up the backdrop and I waited for it to look just messy enough in Jackie's back pocket. The customers of the ice-cream stand were very confused and became pretty vocal: "Miss, did you sit on your cone?" etc. After about twenty photos we knew we had it and treated ourselves to fresh cones. Unique scenarios like this made the production of some of these images really exciting.

Another interesting one to shoot was the New Mexico image. I borrowed many rocks from an abandoned gas station's parking lot, then painted each one to eventually form a gradient. When it came time to carry them to "my studio," a room on my mother's home's second floor, I didn't realize how physical the process would be! I could carry only about three rocks at a time, so I took many trips up and down the steps. When the shooting was completed I returned the painted rocks to the gas station. They stuck out like a sore thumb!

All of my shoots in Pennsylvania were uniquely interesting, but the majority of the photographs were shot at my studio in New York. My process in the city was mostly based around sourcing the correct props and faces to fit each scenario. Once I had all of the moving pieces gathered, it was very satisfying to watch each photograph come to life.

In **ALABAMA** it is illegal to have an ice cream
 cone in your back pocket at all times.

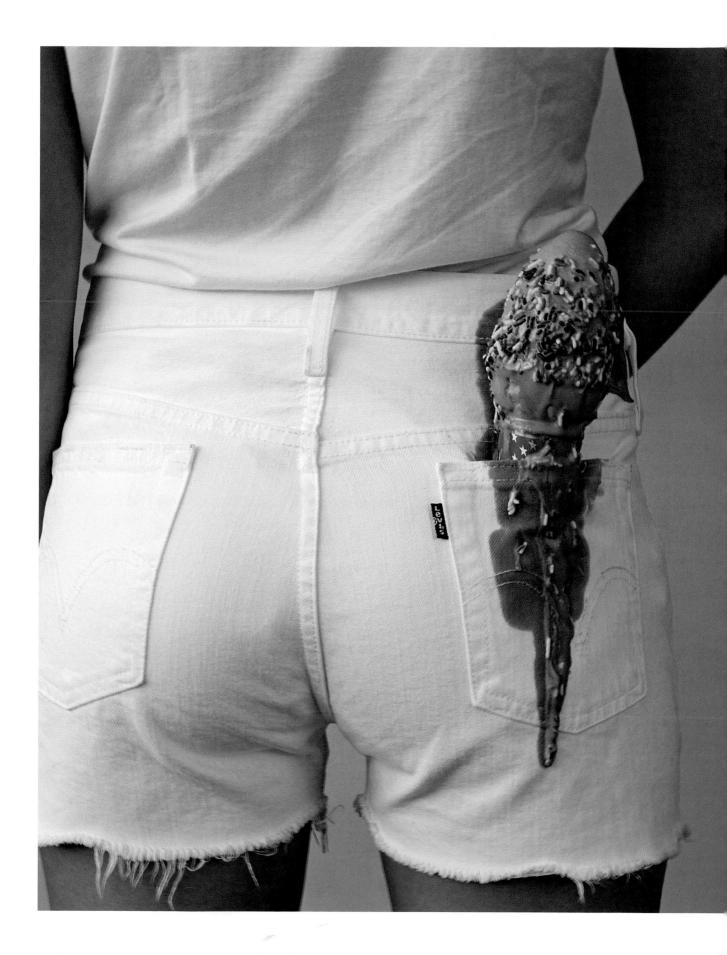

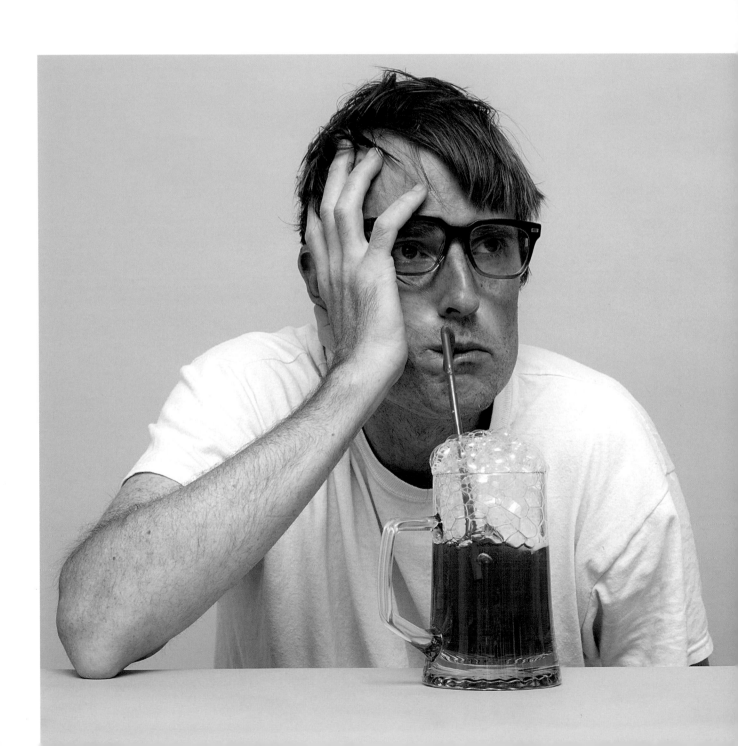

In **ALASKA** it is illegal for an intoxicated person to be in an establishment that serves alcohol.

In ARIZONA you may not have more
than two dildos in a house.

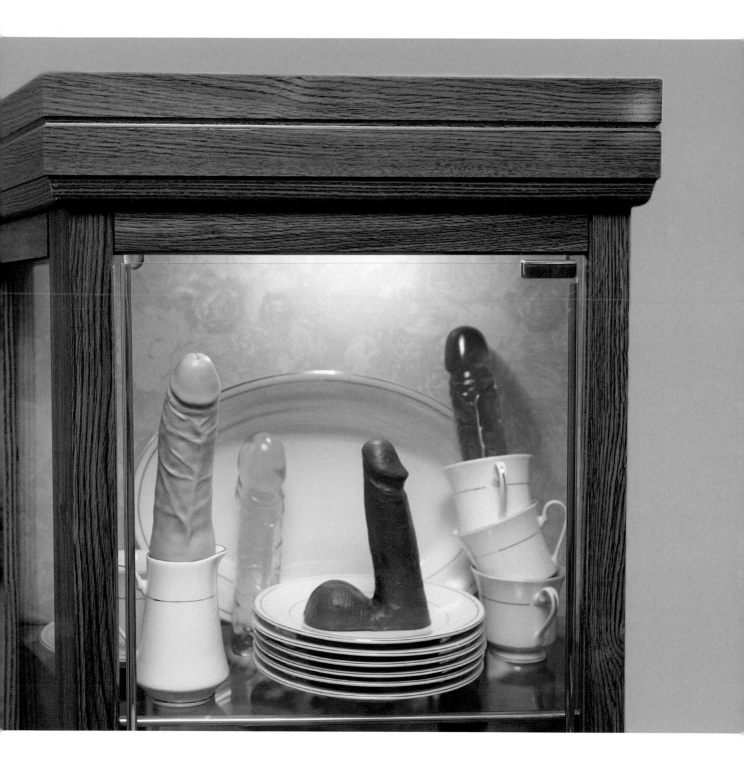

In **ARKANSAS** it is illegal to kill
or preserve any living creature.

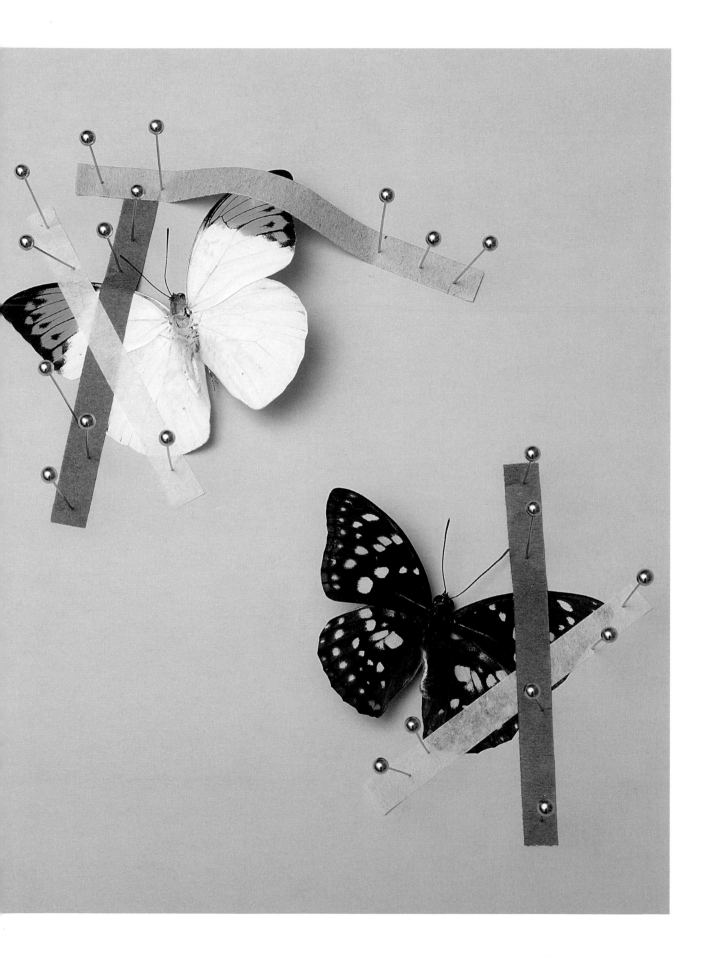

In **CALIFORNIA** nobody is allowed to ride a bicycle in a swimming pool.

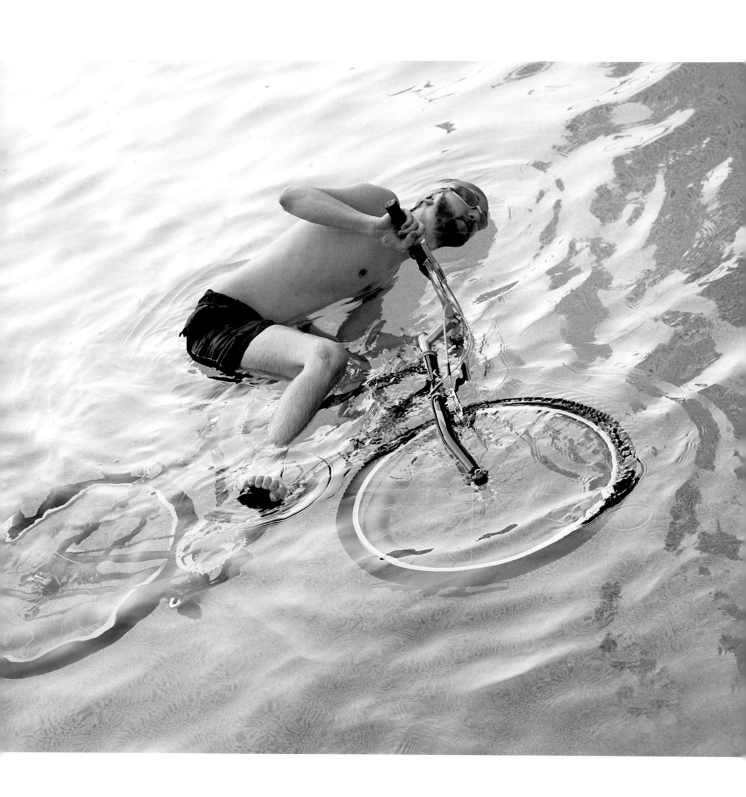

In **COLORADO** it is illegal to
have weeds in your yard.

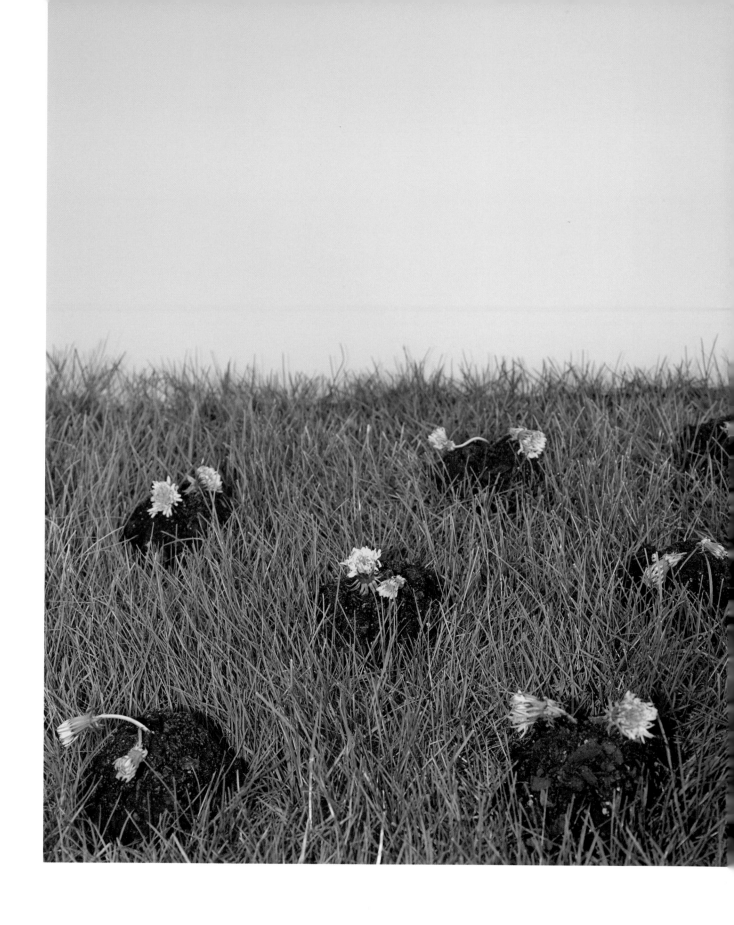

In **CONNECTICUT** pickles must bounce to officially be considered pickles.

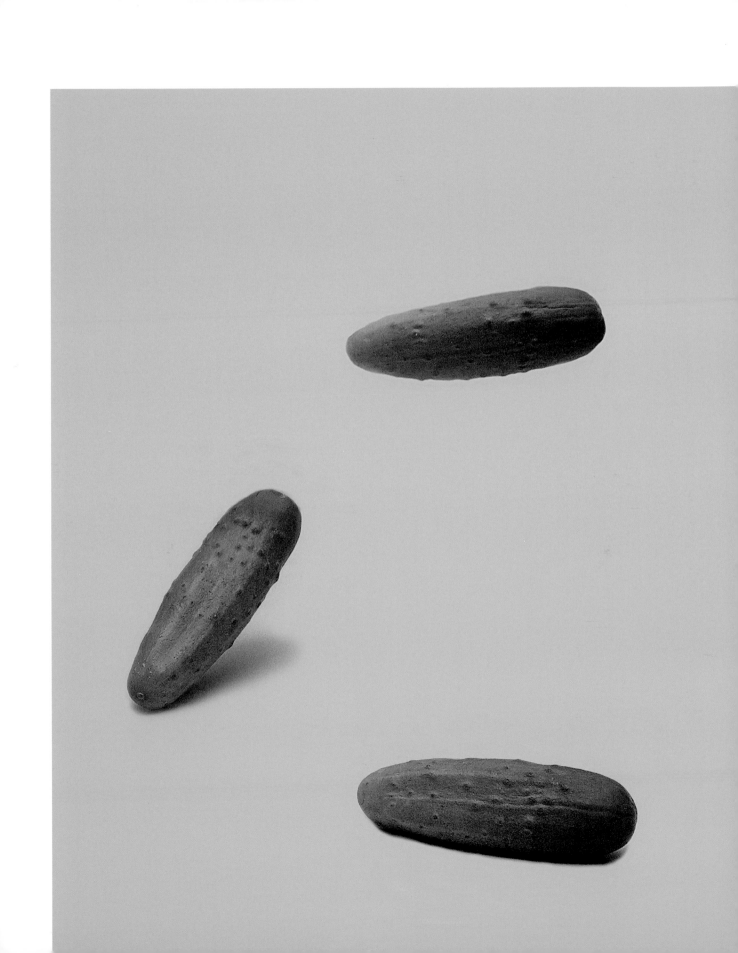

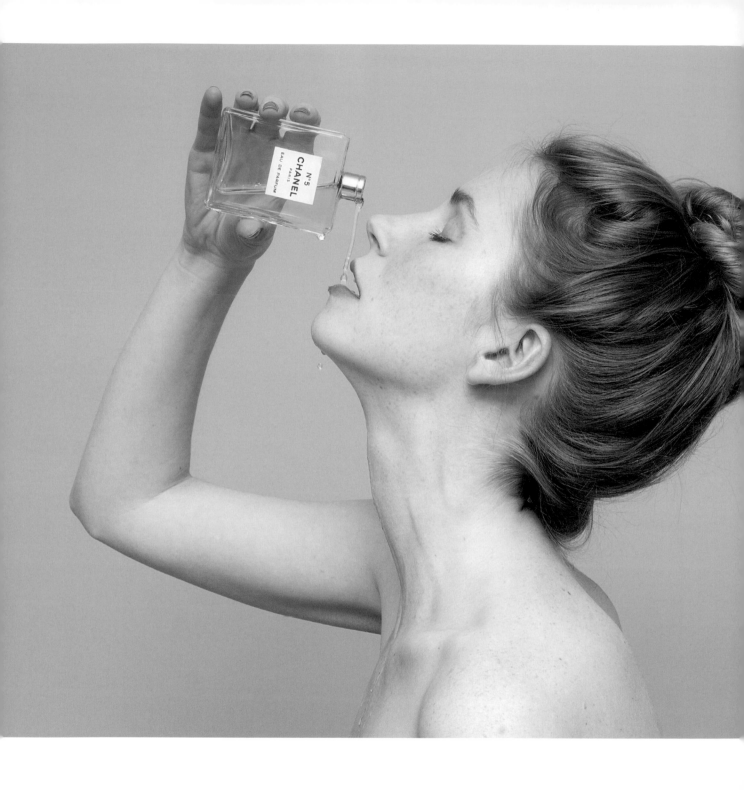

In **DELAWARE** it is illegal to consume perfume.

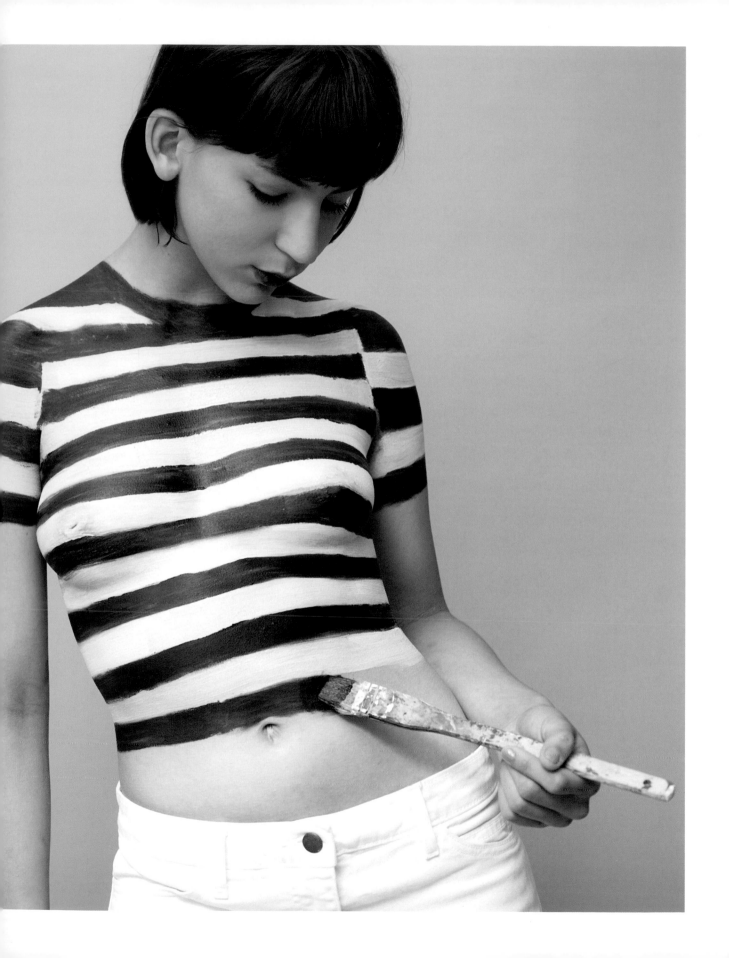

In **FLORIDA** a person may not appear in public clothed in liquid latex.

In **GEORGIA** picnics are prohibited in graveyards.

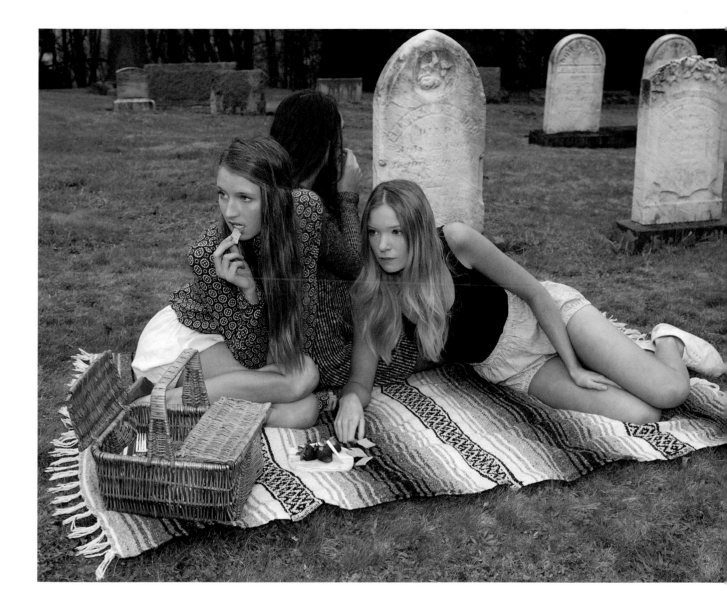

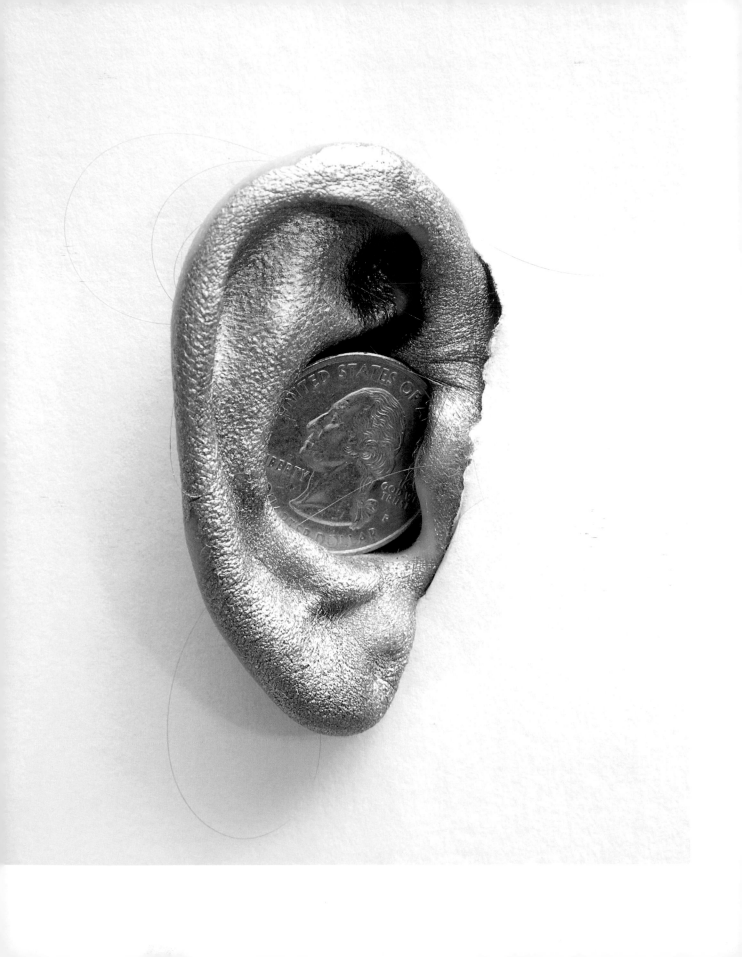

In **HAWAII** it is illegal to place a coin in your ear.

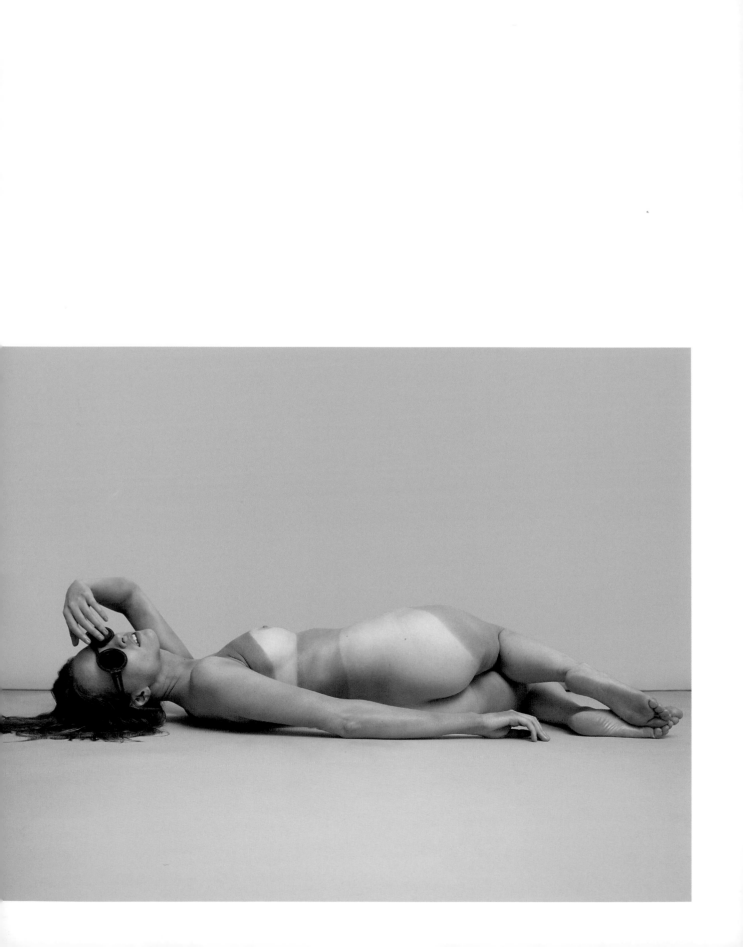

In **IDAHO** it is illegal to be nude outdoors, even on private properties.

In ILLINOIS a hatpin is considered
a concealed weapon.

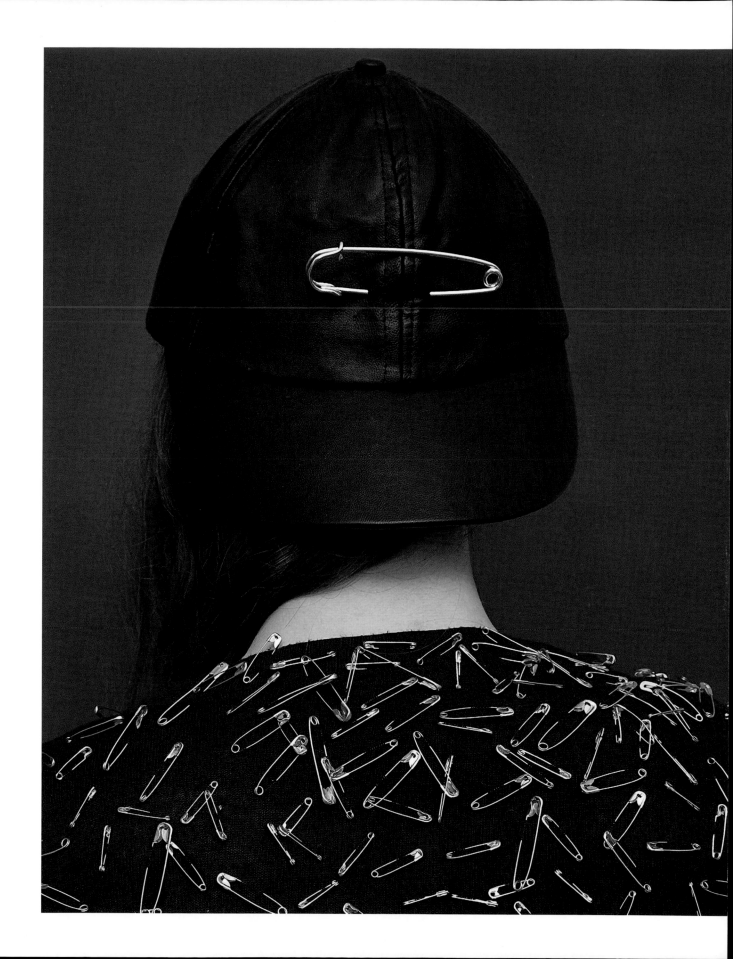

In **INDIANA** it is illegal for a man
to be sexually aroused in public.

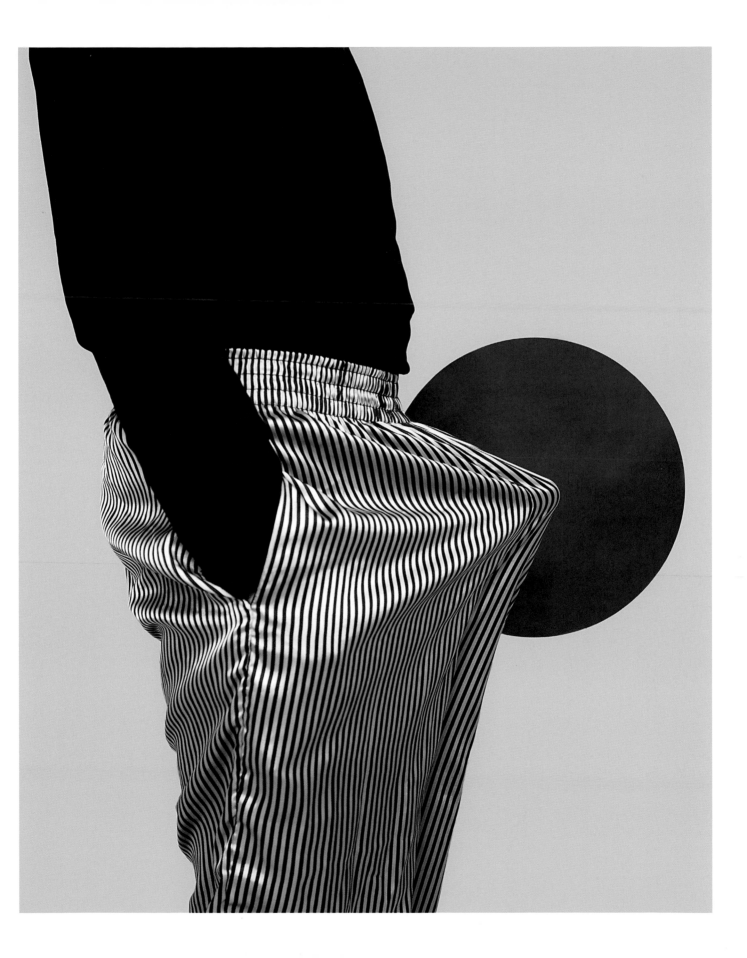

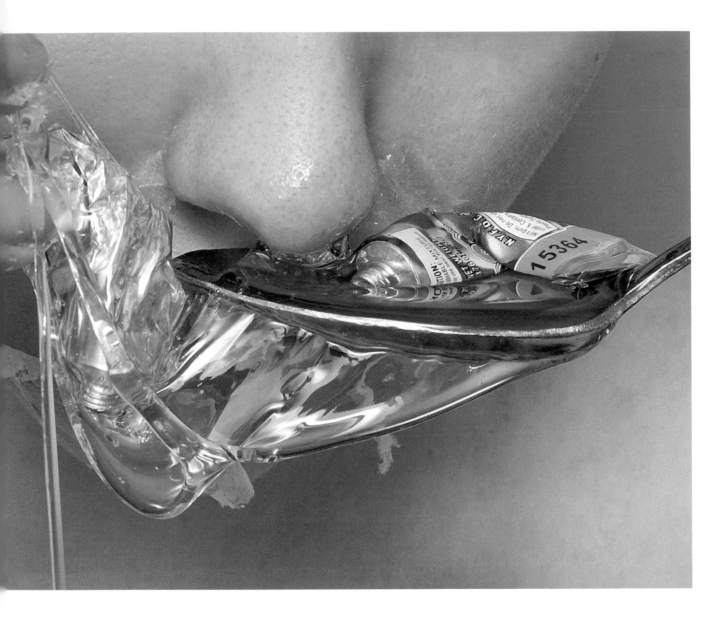

In IOWA it is illegal to sniff glue.

In **KANSAS** it is illegal to
serve wine in teacups.

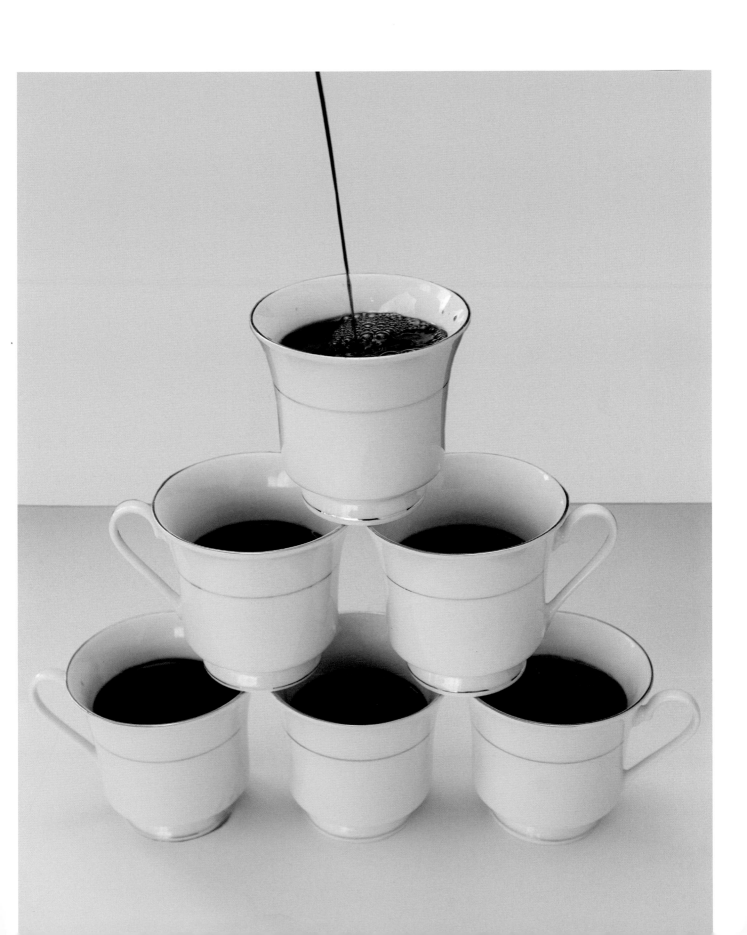

In **KENTUCKY** it is illegal to lick a toad.

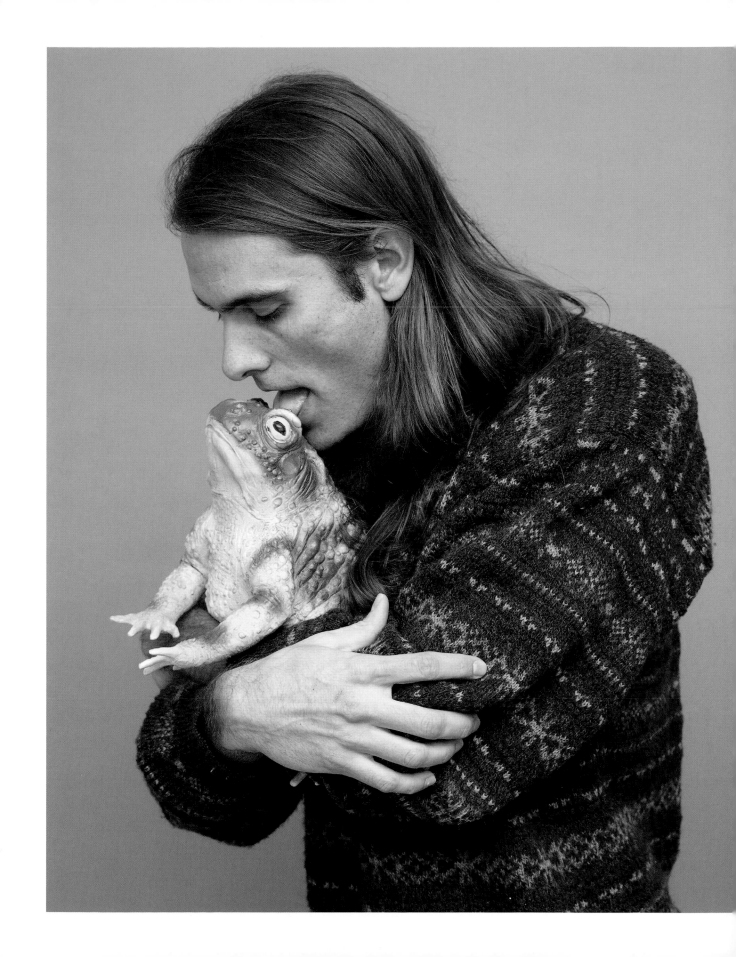

In **LOUISIANA** it is illegal to gargle in public.

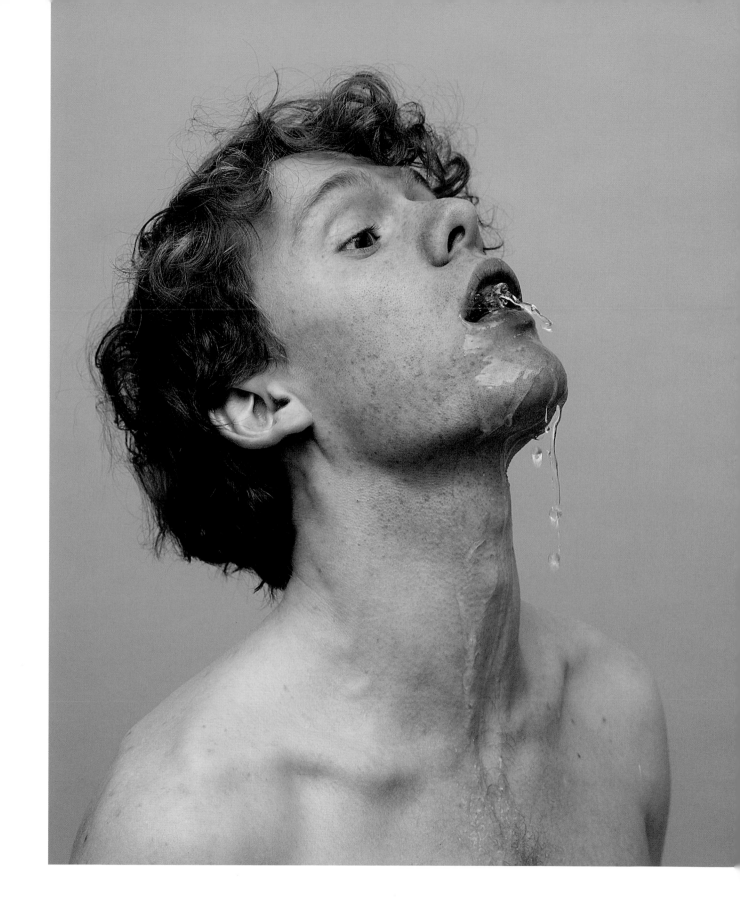

In **MAINE** it is illegal to mail prescription drugs unless you're a licensed pharmacist.

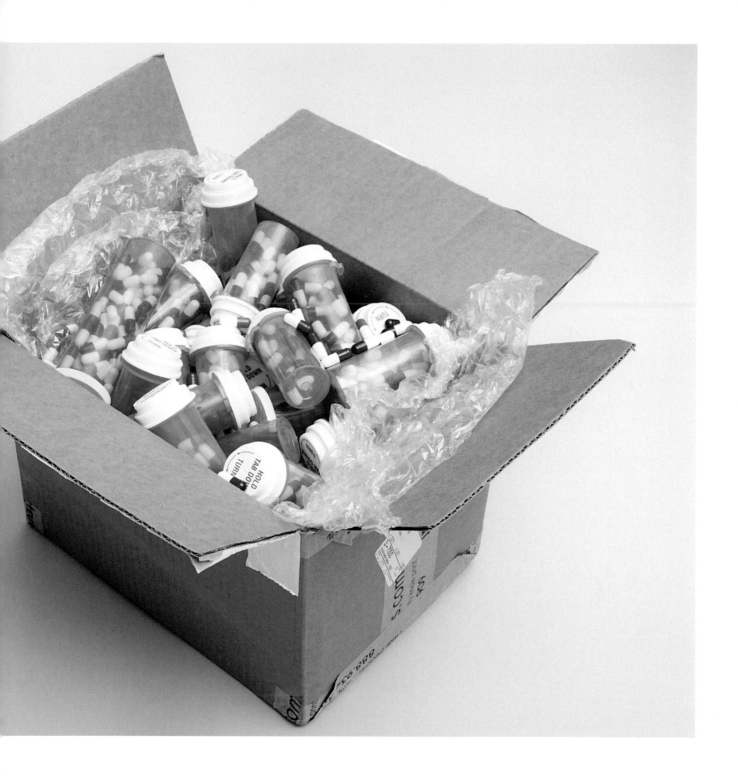

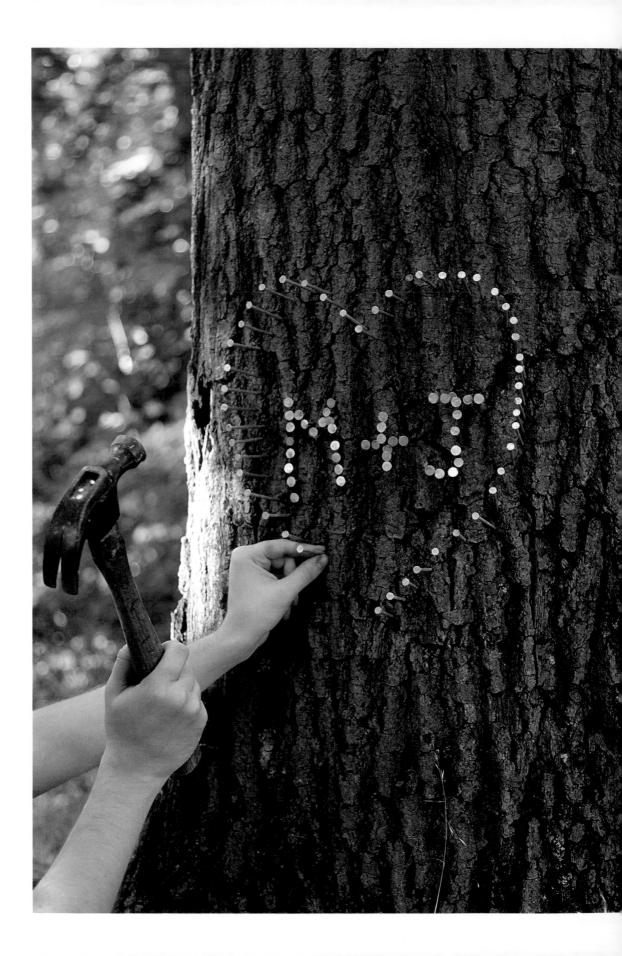

In **MARYLAND** hammering a nail into a tree
is punishable by a fifty-dollar fine.

In **MASSACHUSETTS** photographing up-skirt
photos can be considered a crime.

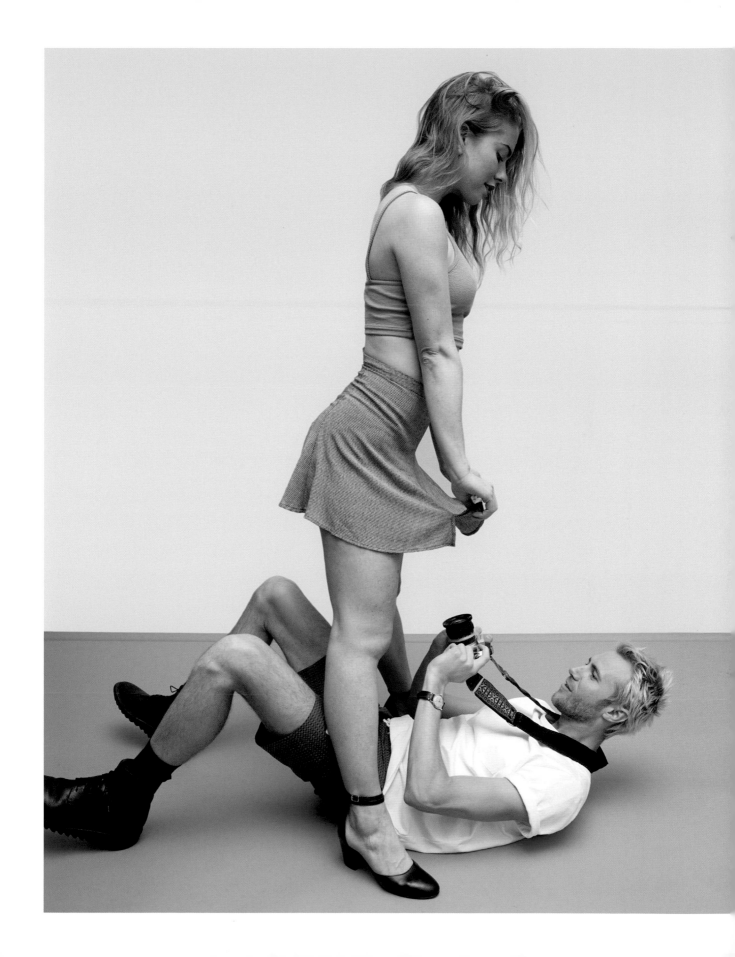

In **MICHIGAN** it is illegal to paint sparrows with
the intention of selling them as parakeets.

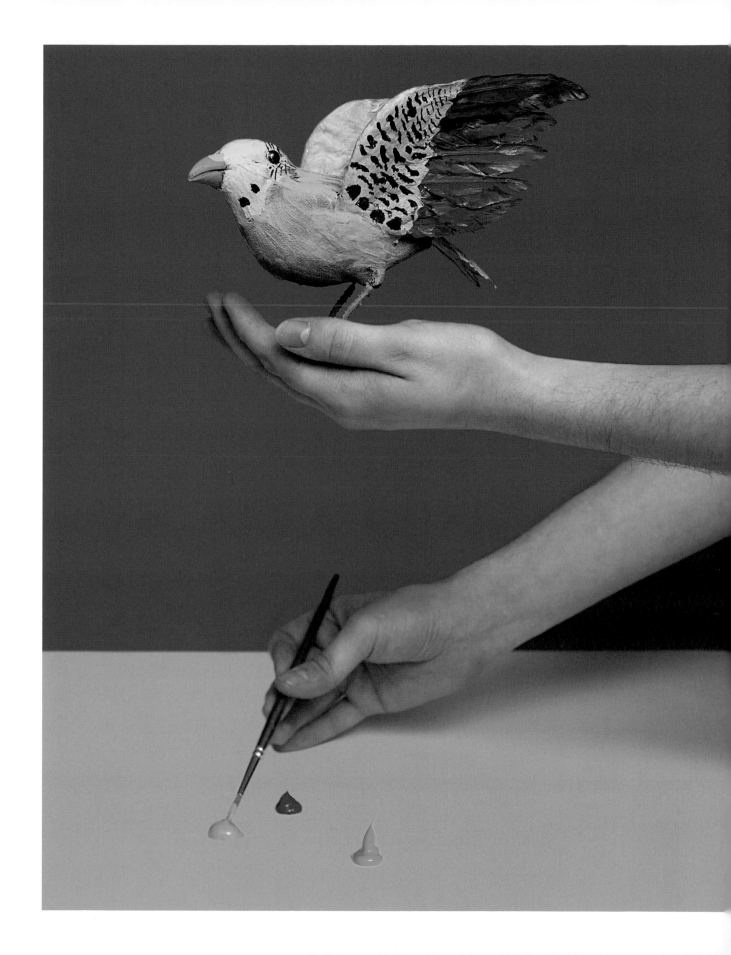

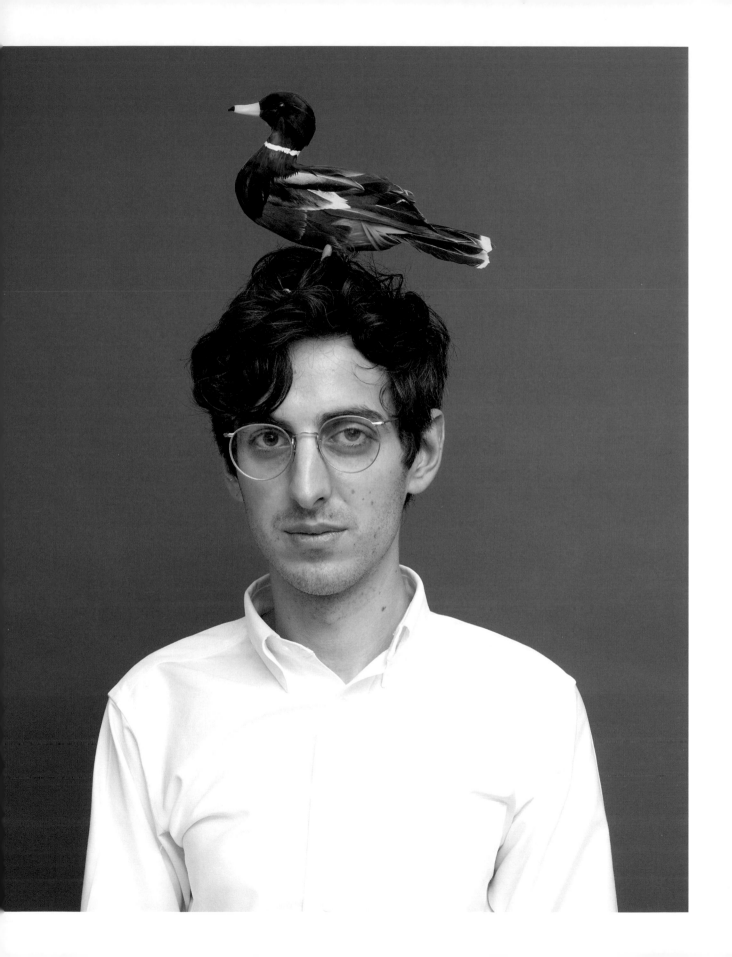

In **MINNESOTA** it is illegal for a person to cross state lines with a bird atop their head.

In **MISSISSIPPI** *Sesame Street* was banned
from television in 1970.

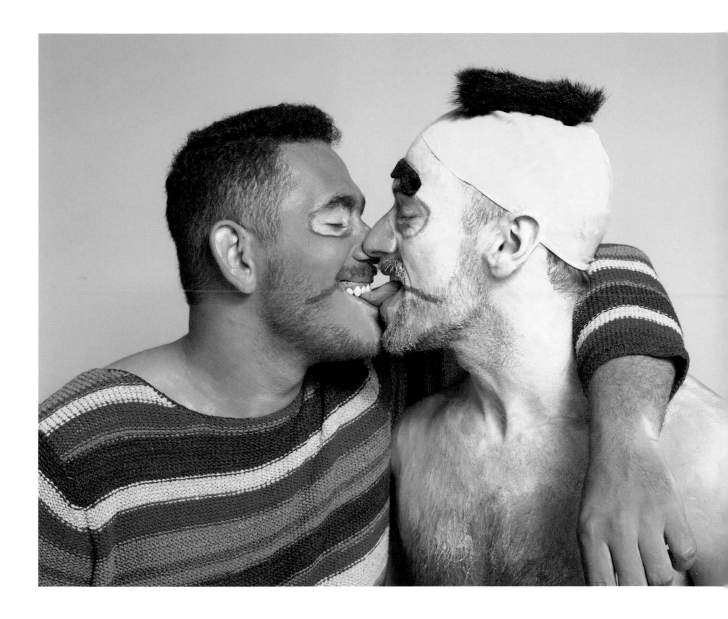

In **MISSOURI** it is illegal to
deface a milk carton.

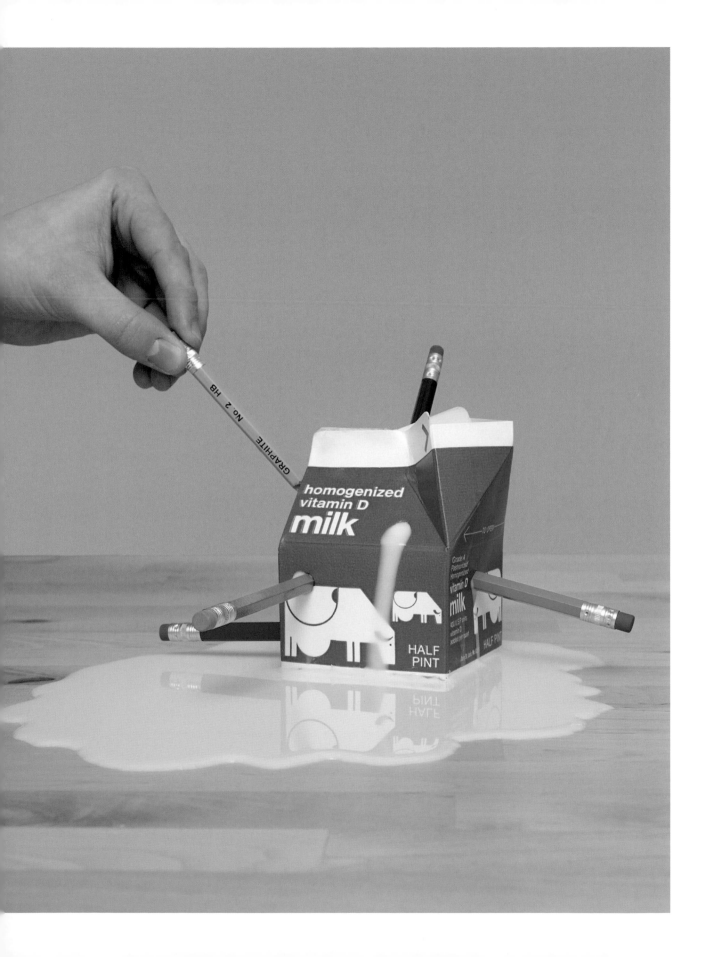

In **MONTANA** there is a ban
on low-riding trousers.

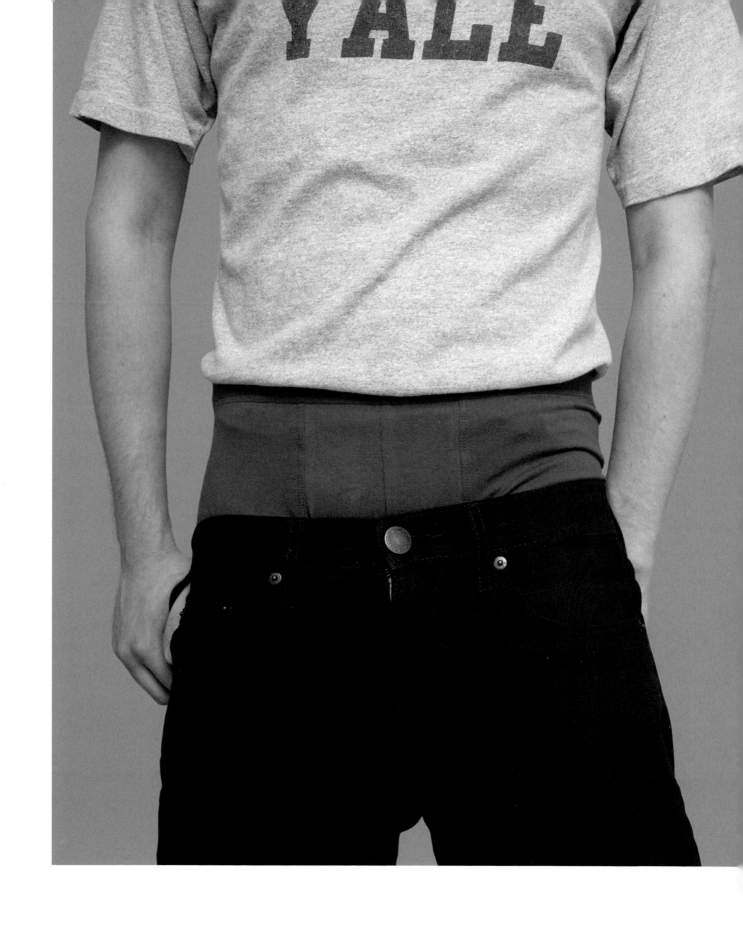

In NEBRASKA it is illegal for parents to perm
 their child's hair without a state license.

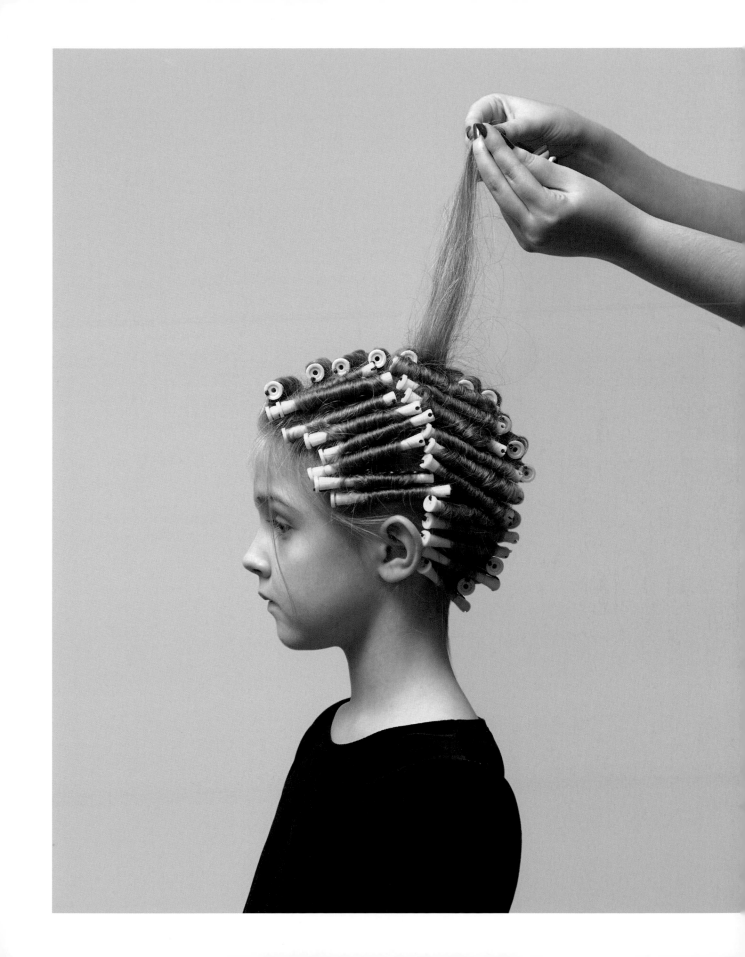

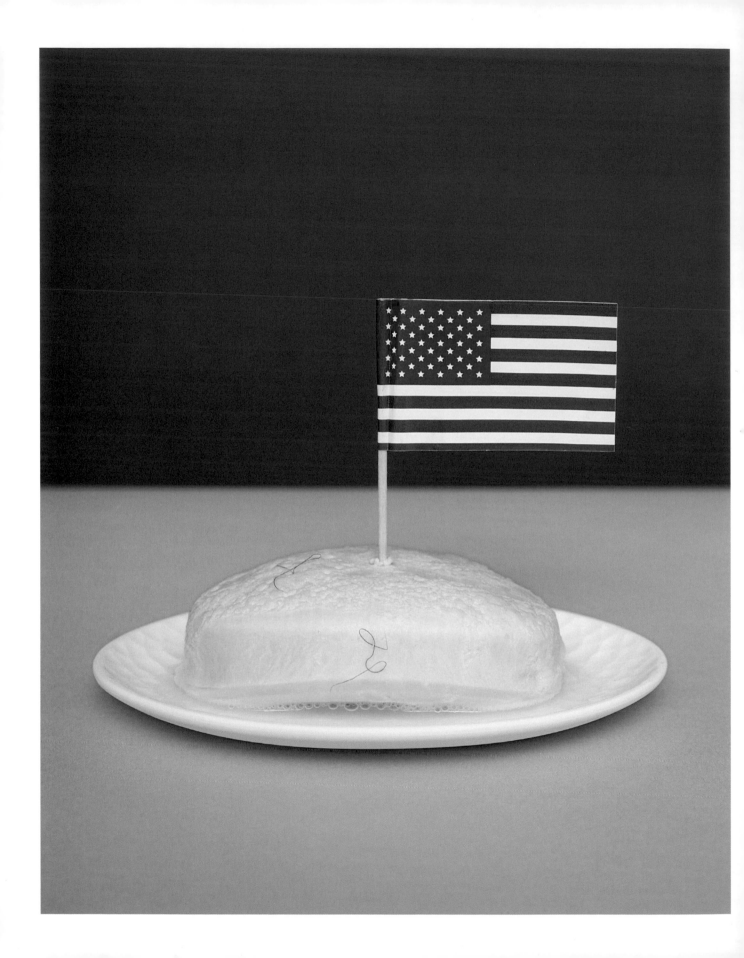

In **NEVADA** it is illegal to put an
American flag on a bar of soap.

In **NEW HAMPSHIRE** you can't tap your foot to keep time to music.

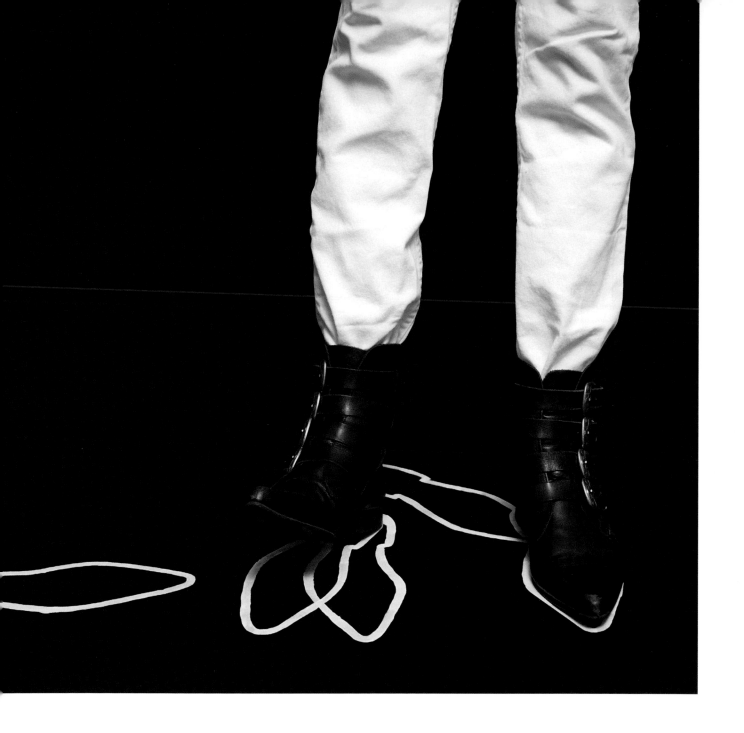

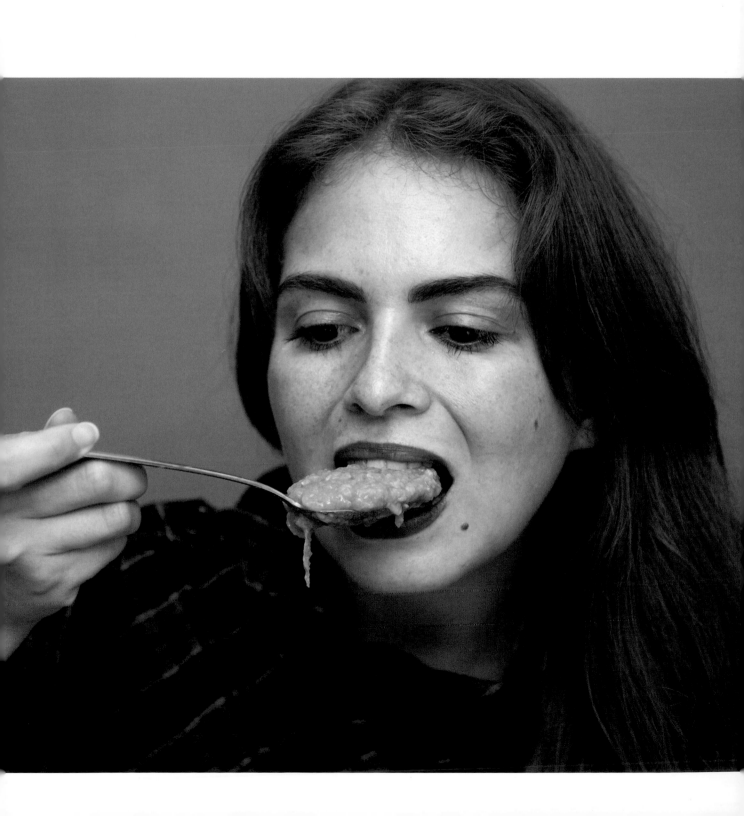

In **NEW JERSEY** a person can be arrested
for slurping soup in public.

In NEW MEXICO defacing rocks is a crime.

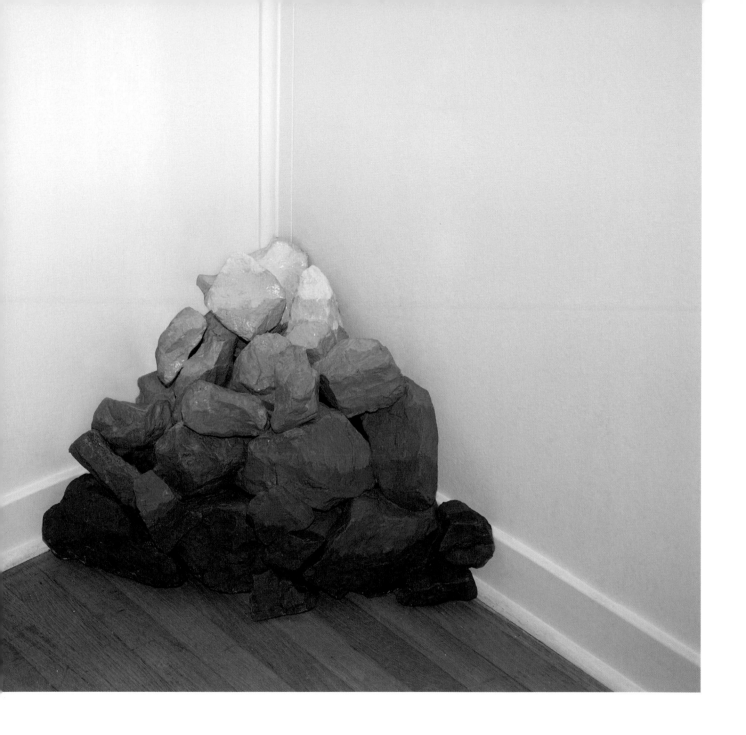

In **NEW YORK** students eighteen years and older
can be arrested for cheating on exams.

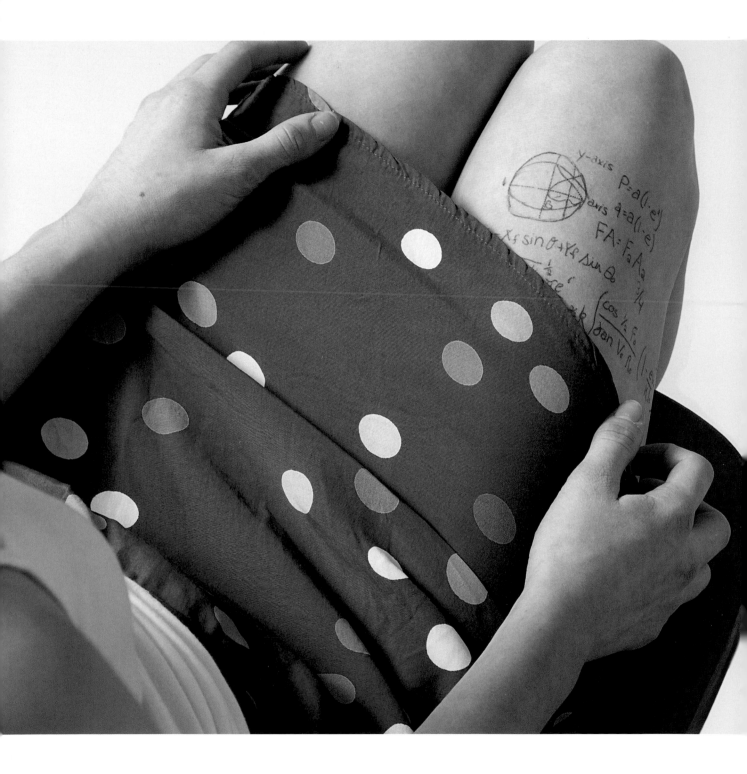

In **NORTH CAROLINA** it is a misdemeanor
to urinate on someone else's property.

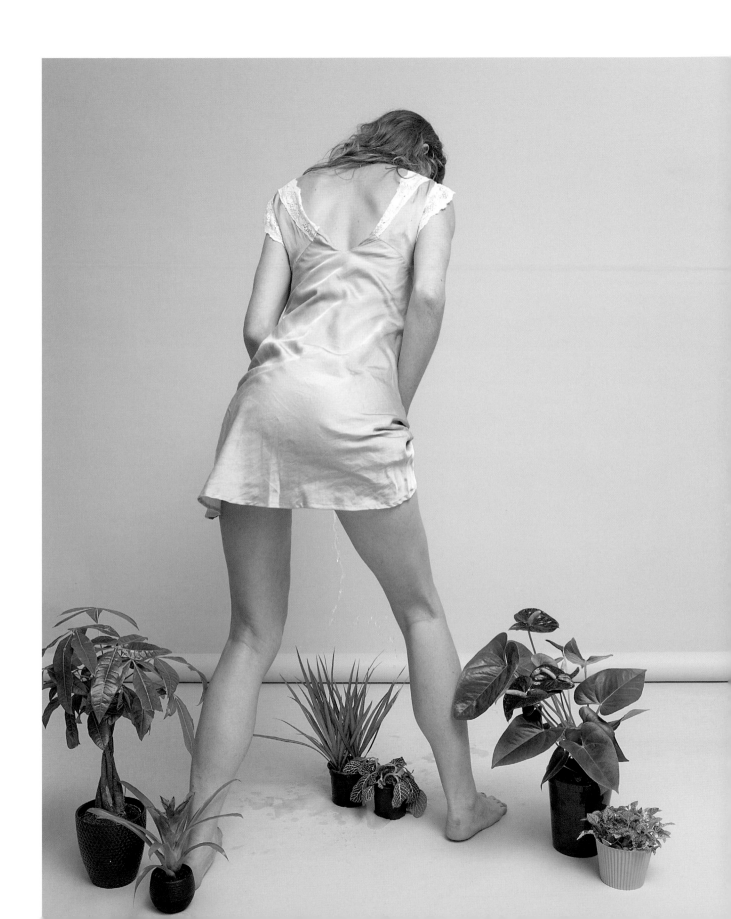

In **NORTH DAKOTA** it is illegal to
fall asleep with shoes on in bed.

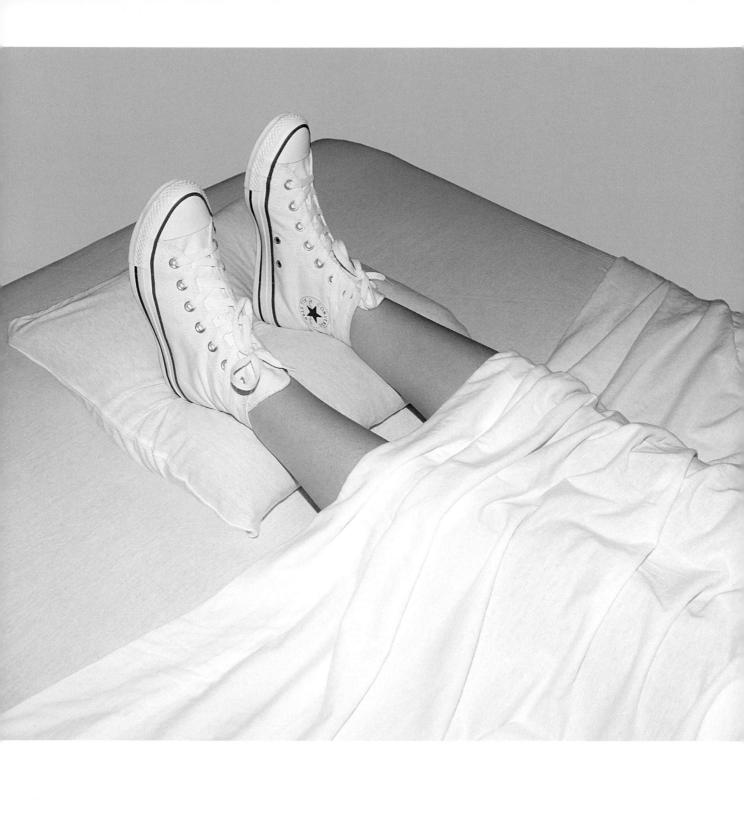

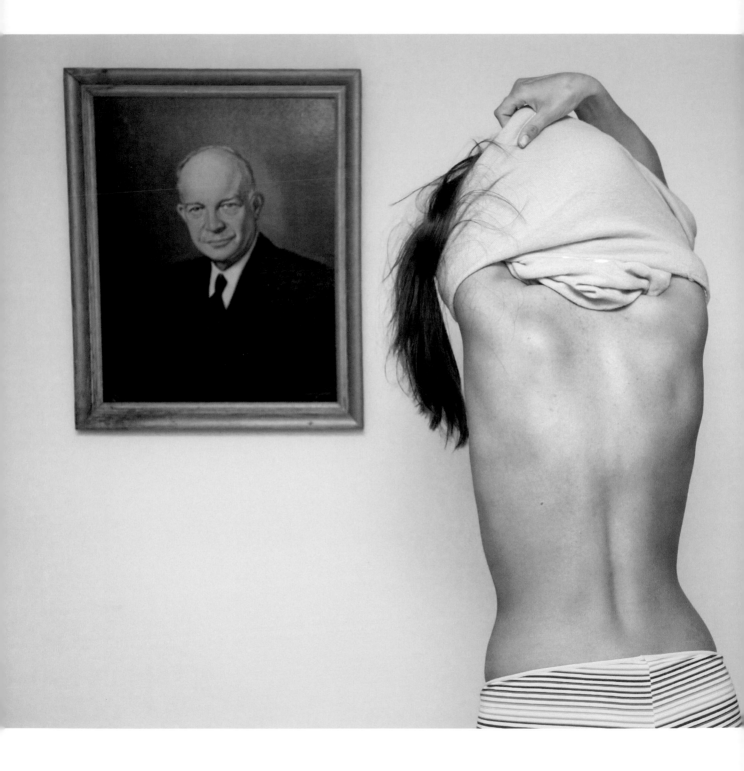

In **OHIO** it is illegal to disrobe in
front of a portrait of a man.

In **OKLAHOMA** it is illegal to put
a hypnotized person on display.

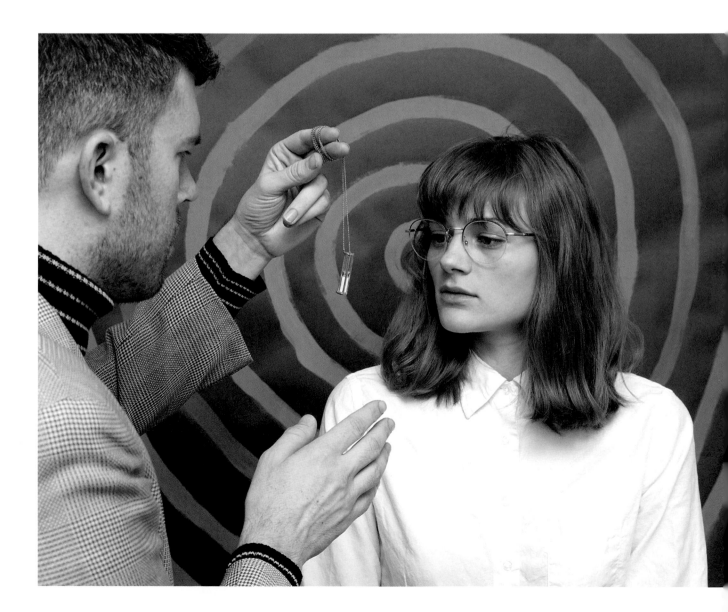

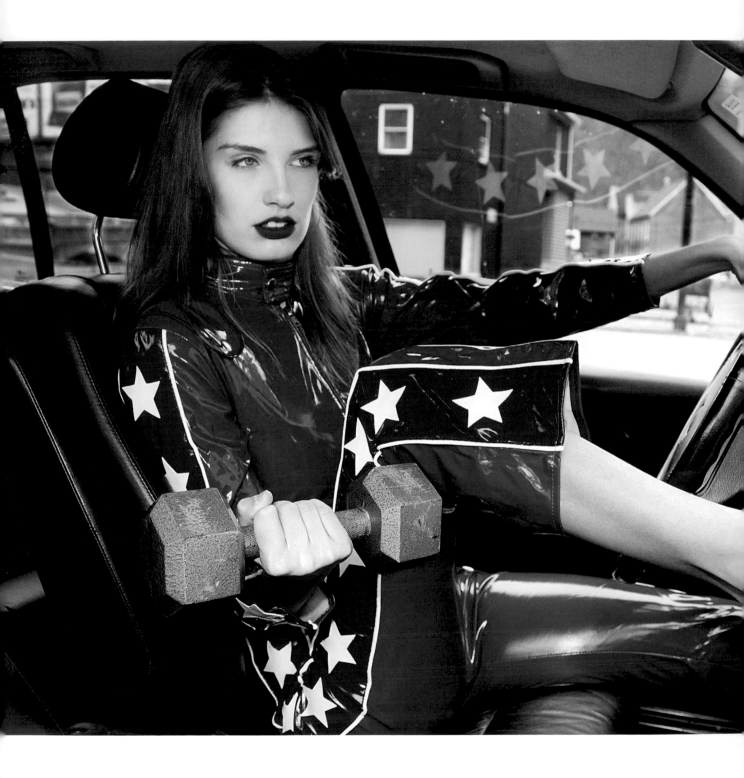

In **OREGON** people may not test their physical endurance while driving a car on a highway.

In **PENNSYLVANIA** it is illegal to tie a dollar
bill to a string and pull it away when
someone tries to pick it up.

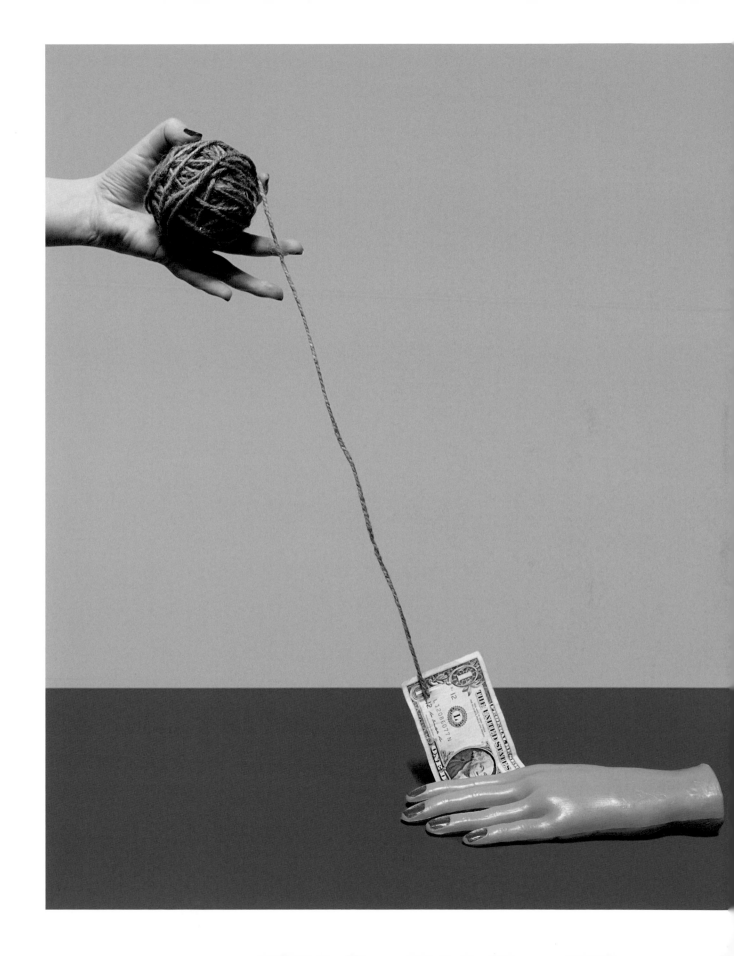

In **RHODE ISLAND** it is illegal
to wear transparent clothing.

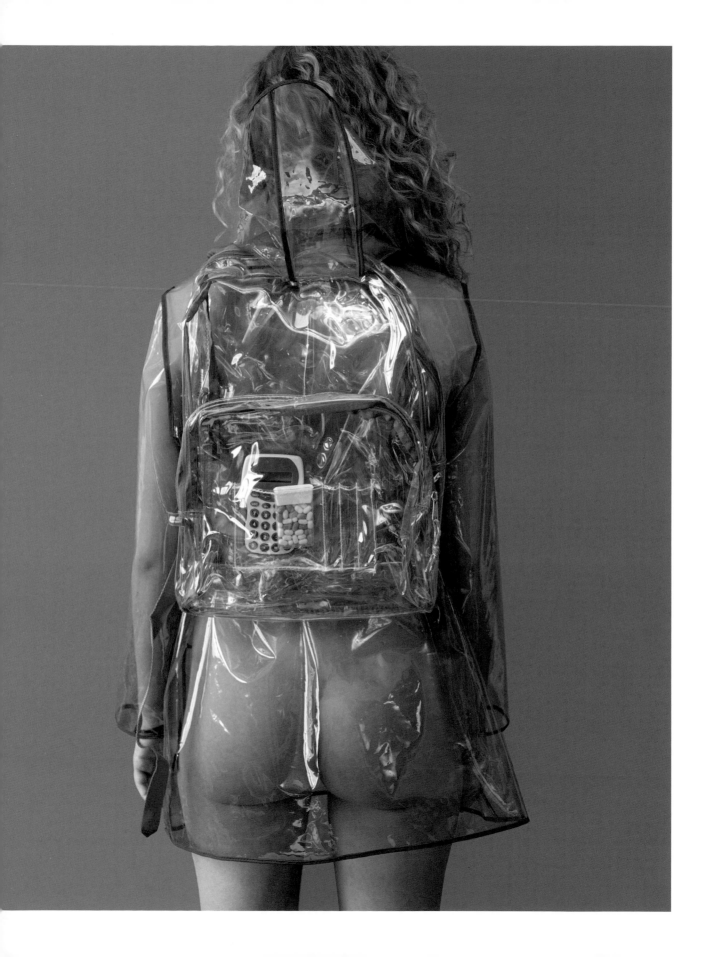

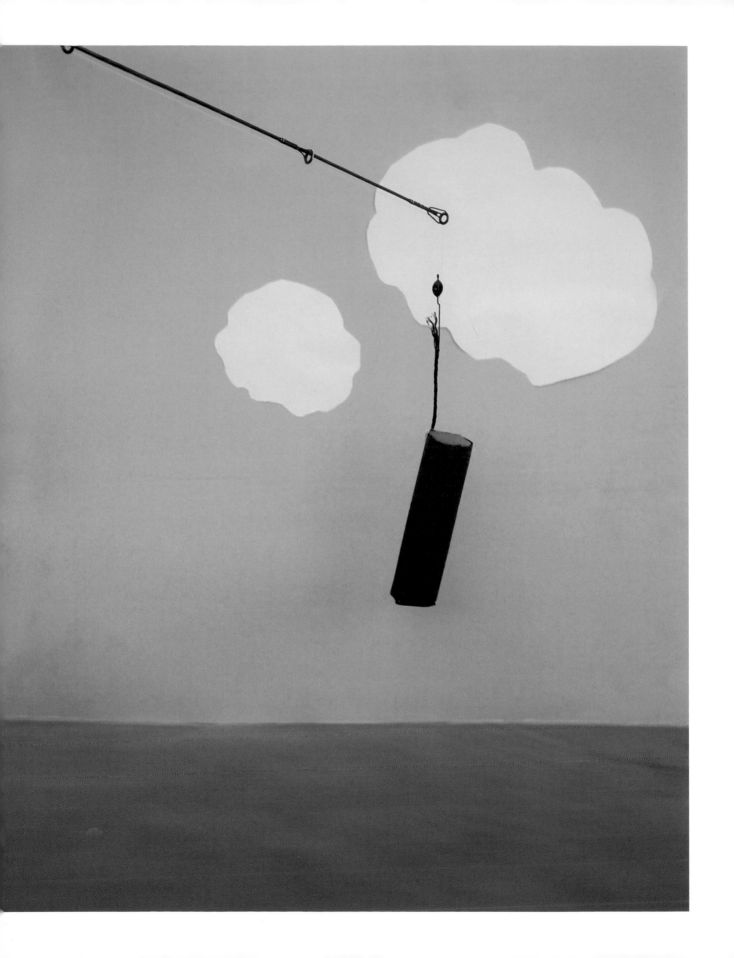

In **SOUTH CAROLINA** it is illegal to go
fishing with dynamite.

In **SOUTH DAKOTA** it is unlawful to cause static.

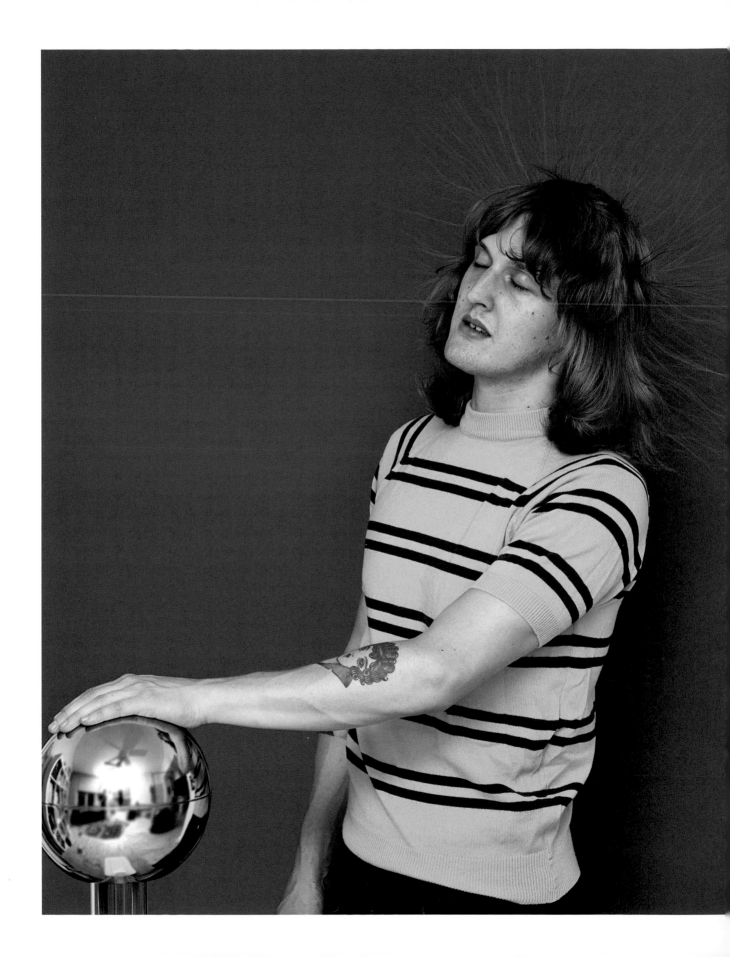

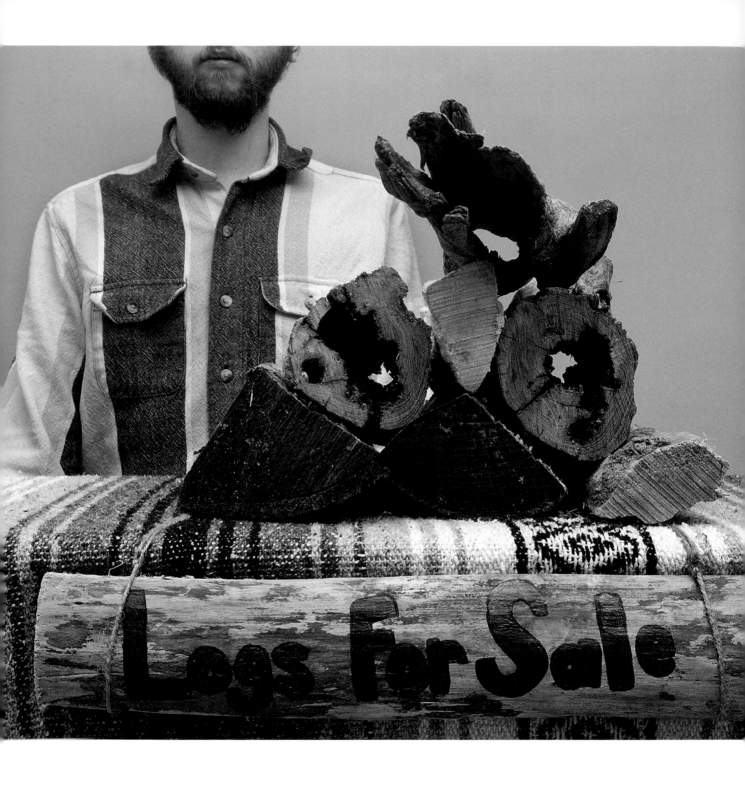

In **TENNESSEE** hollow logs may not be sold.

In **TEXAS** it is illegal for children
to have unusual haircuts.

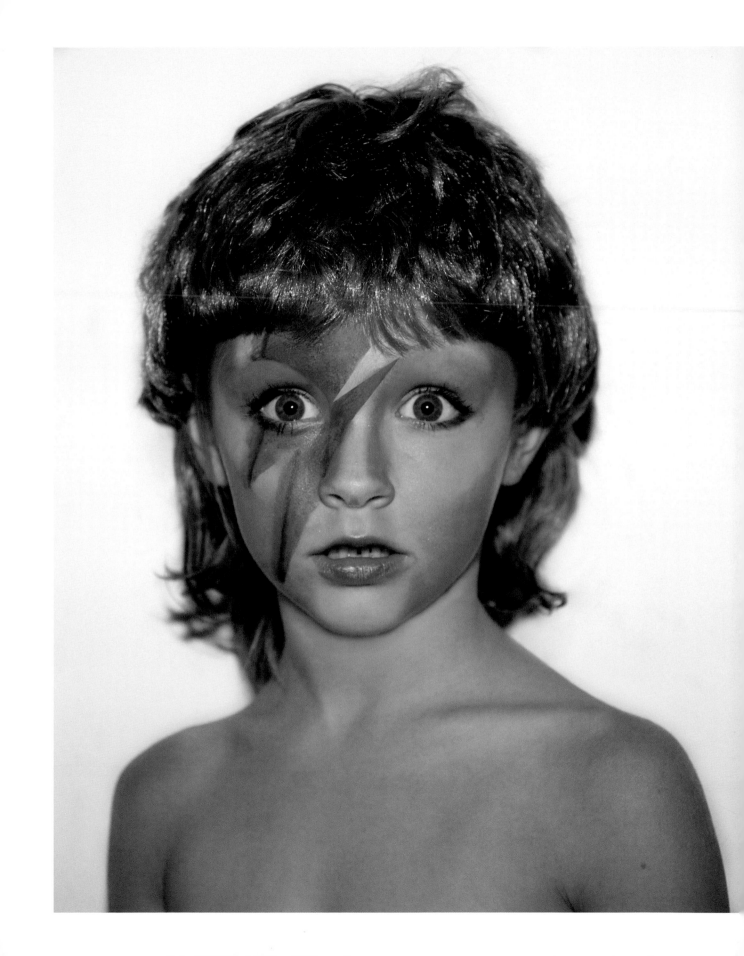

In **UTAH** no one may walk down the street carrying
a paper bag containing a violin.

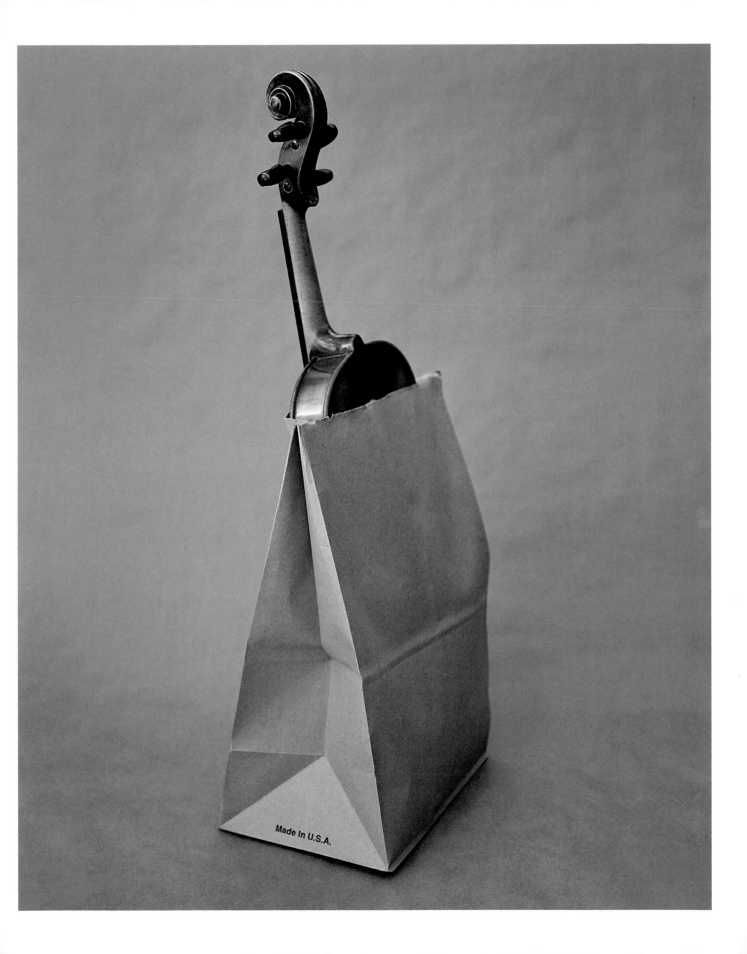

In **VERMONT** it is illegal to use colored
margarine in restaurants unless the
menu indicates you do.

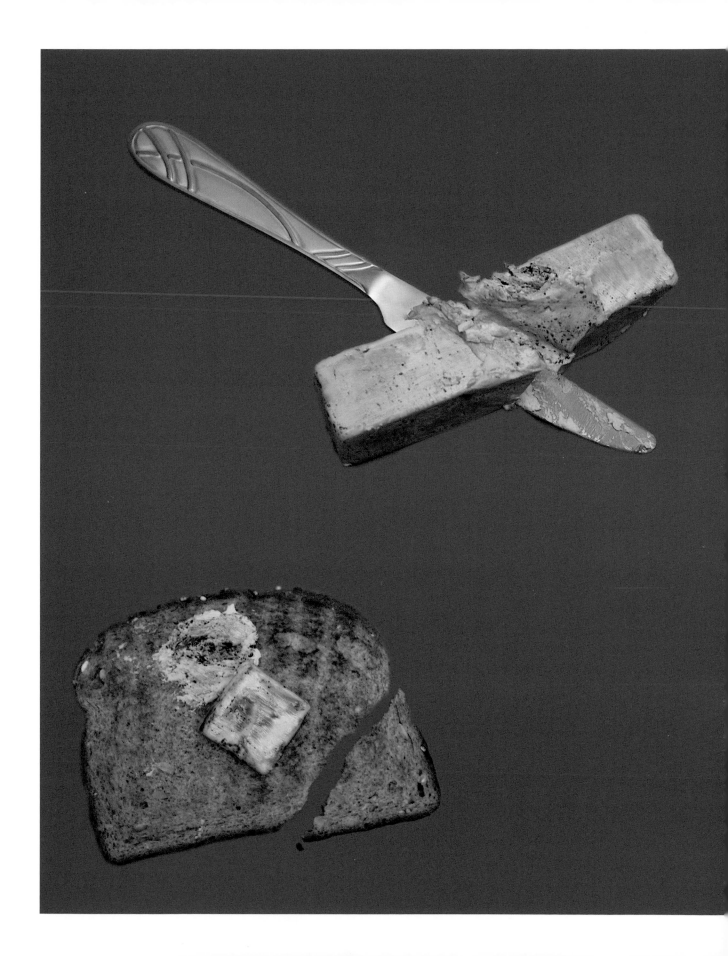

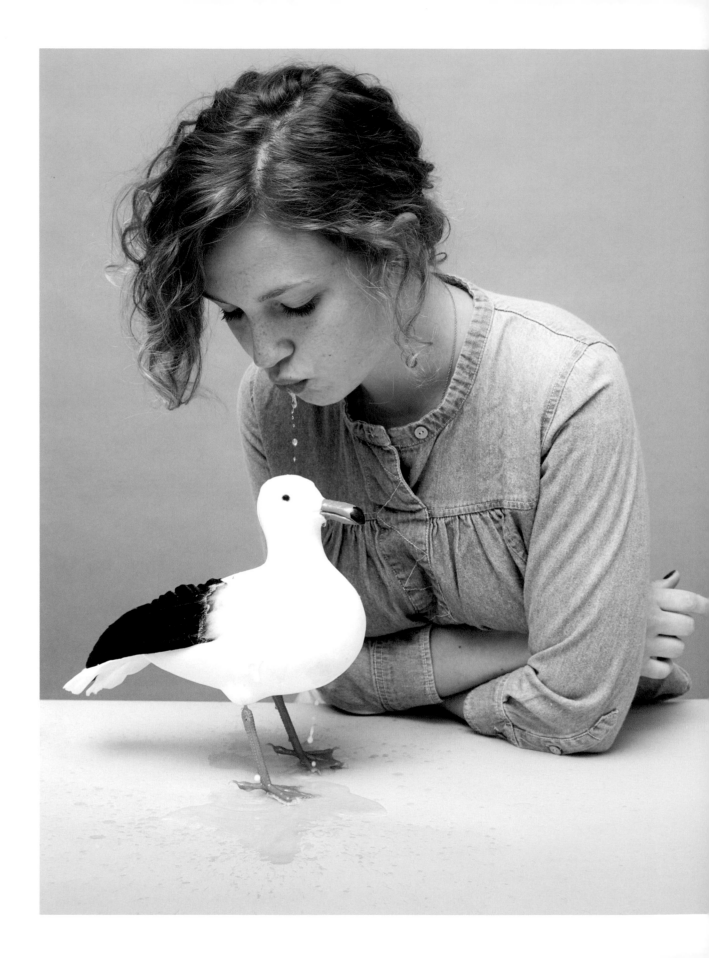

In **VIRGINIA** spitting on a sea gull is punishable by a fine.

In WASHINGTON it is illegal to paint
polka dots on the American flag.

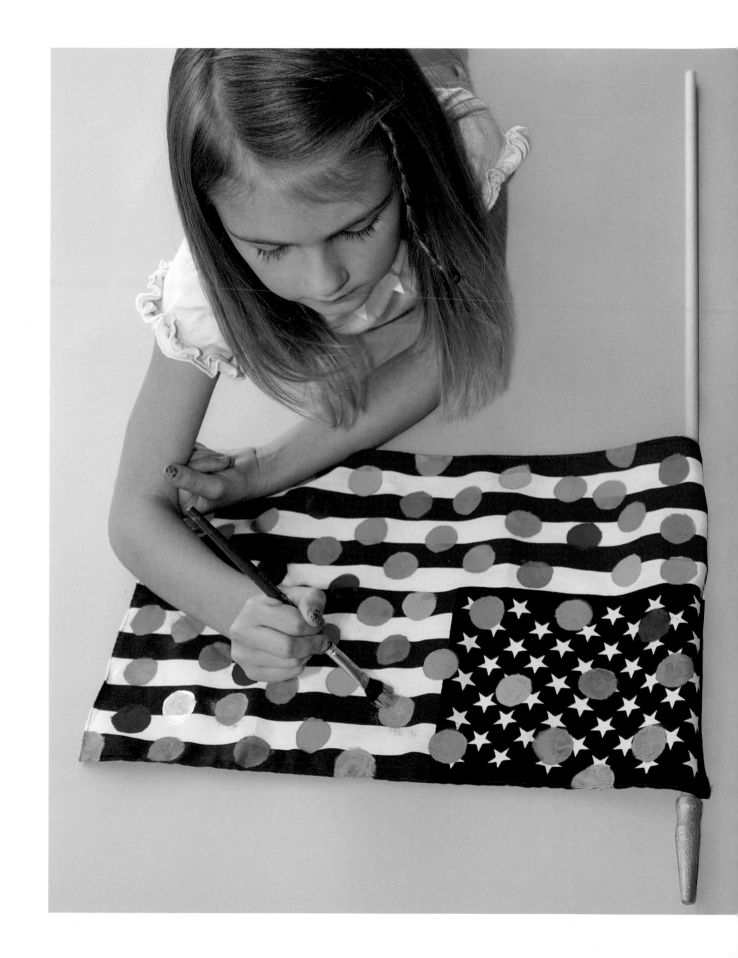

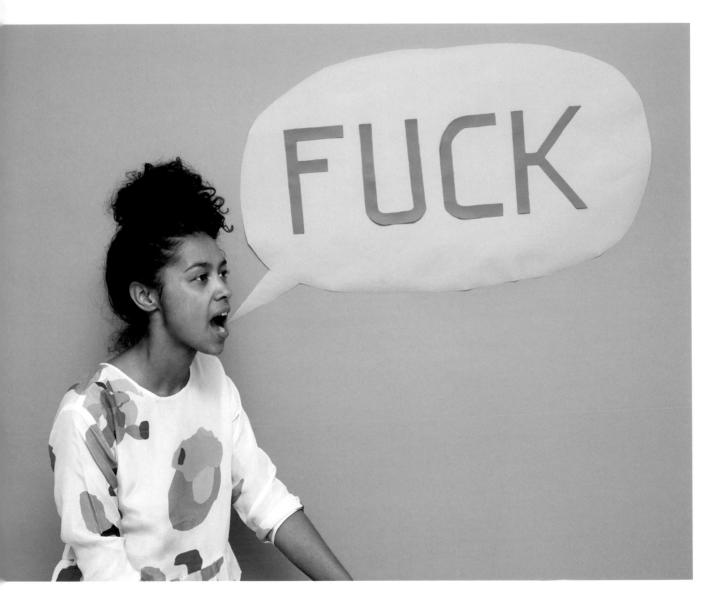

In **WEST VIRGINIA** swearing can be punishable
by a fine.

In **WISCONSIN** it is illegal to serve apple pie
in public restaurants without cheddar cheese

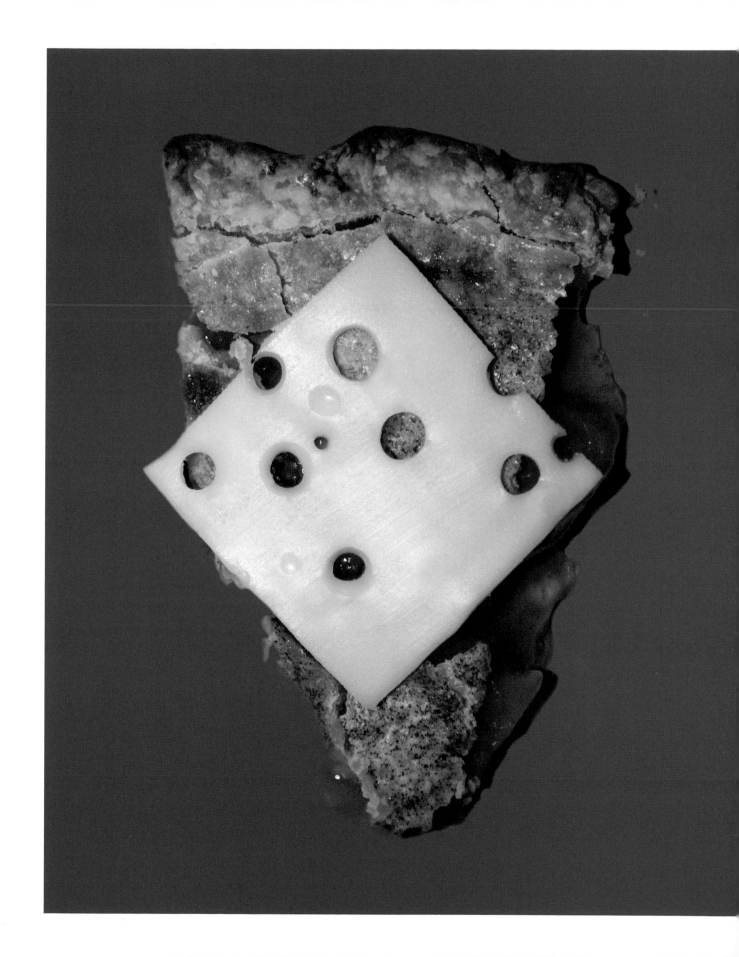

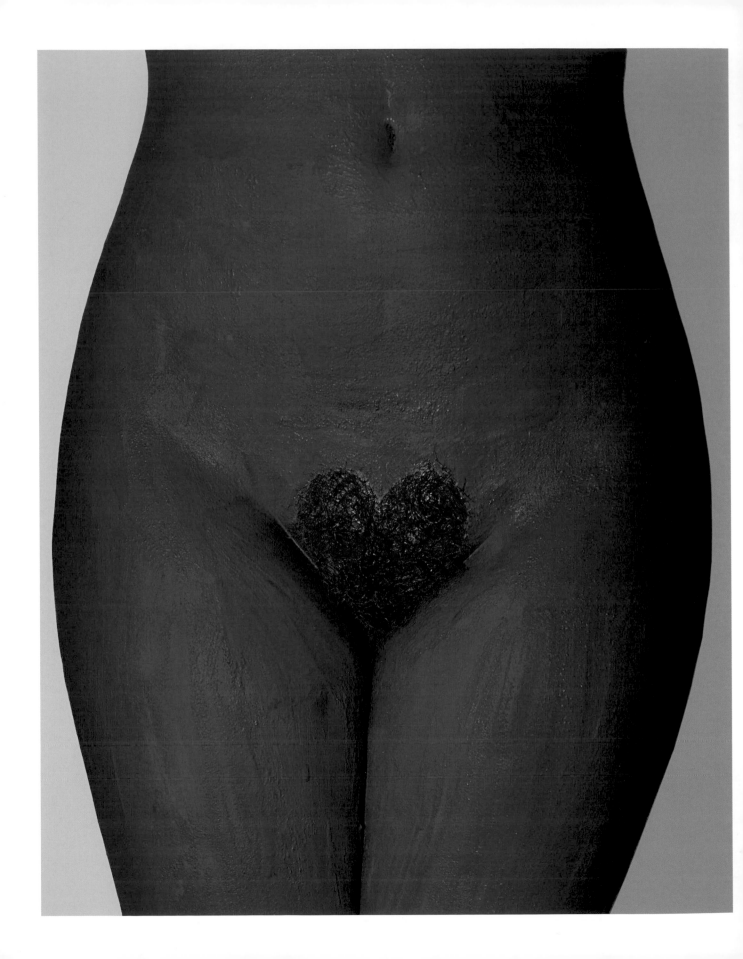

In **WYOMING** it is illegal for a hairdresser to groom a customer's pubic hair.

Library of Congress Cataloging-in-
Publication Data
Names: Goldsmith, Kenneth, writer
of foreword. | Locher, Olivia,
photographer
 (expression) | Shiner, Eric C.,
 interviewer. | Locher, Olivia.
 Photographs. Selections.
Title: I fought the law : photographs
by Olivia Locher of the strangest
laws
 from each of the 50 states /
 photographs X Olivia Locher ;
 foreword X
 Kenneth Goldsmith ; interview X
 Eric Shiner.
Description: San Francisco :
Chronicle Books, [2017]
Identifiers: LCCN 2016039250 | ISBN
9781452156958 (alk. paper)
Subjects: LCSH: Photography,
 Humorous. | Staged photography—
 United States. |
 Law—United States—States—Humor.
 | Law—United
 States—States—Miscellanea.
Classification: LCC TR679.5 .I15 2017
| DDC 779—dc23 LC record available at
https://lccn.loc.gov/2016039250

Manufactured in China

Design by TAYLOR ROY

10 9 8 7 6 5 4 3 2

Chronicle Books LLC
680 Second Street
San Francisco, California 94107

WWW.CHRONICLEBOOKS.COM

Acknowledgments

X Thank you!
The Andy Warhol Museum, Olivia Bee, Christopher Bell, Marc Joseph Berg, Blake Burkholder, Jessica Craig-Martin, the David Lynch Foundation, Iris Davis, Kate Davis, Allie Edwards, Matthew Foley, Stephen Frailey, Clare Gillies, Kenneth Goldsmith, Kasey Helmick, Madi Hrin, Marc Jacobs, Zoe Johnson, Steven Kasher, Eleanor Kriseman, Danny Lane, Look3, Gina Martin, Nion McEvoy, Jennifer Medina, Felipe Mendes, Ana Mendez-Villamil, Hamilton Morris, Erika Mugglin, Josie Niovich, Andrew Owen, Derek Peel, Andi Potamkin Blackmore, Derek Reighard, Taylor Roy, Kathy Ryan, Marcel Saba, the School of Visual Arts, Olivia Seally, Sara Sevier Anderson, Eric Shiner, Alex Silva, Steven Kasher Gallery, Billy Sullivan, Miwa Susuda, Emma Swanson, Britt Tapsall, Scott Thode, Jackie Thornton, Jesse Turits, Sam Valenti IV, Bridget Watson Payne, Matthew Werth, Erin Weyant, Lilly Whorl, Ian Williams, and my wonderful family, William Locher Jr., Marianne Locher, and Brandon Locher